NEW
ARTISTS
VIDEO

GREGORY BATTCOCK is editor of several anthologies of criticism in the fine arts, including *The New Art, The New American Cinema, Minimal Art, New Ideas in Art Education, Super Realism* and author of *Why Art*. He teaches art history at The William Paterson College of New Jersey and New York University.

NEW ARTISTS VIDEO

A CRITICAL ANTHOLOGY

Edited by

GREGORY BATTCOCK

A Dutton Paperback

NEW YORK E. P. DUTTON

Library of Congress Catalog Card Number: 77-73146

ISBN: 0-525-47461-7

Published simultaneously in Canada by Clarke, Irwin & Company Limited, Toronto and Vancouver

10 9 8 7 6 5 4 3 2 1

First Edition

Vicky Alliata: "Negative Videology." Printed by permission of the author.
Michael Benedikt: "Poetry and Video Tape: A Suggestion." Printed by permission of the author.
Mona Da Vinci: "Video: The Art of Observable Dreams." Printed by permission of the author.
Douglas Davis: "The End of Video: White Vapor." Printed by permission of the author.
Lynn Hershman: "Reflections on the Electric Mirror." Printed by permission of the author.
Richard Kostelanetz: "Literary Video." Printed by permission of the author.
Rosalind Krauss: "Video: The Aesthetics of Narcissism." Reprinted from October, 1, no. 1 (Spring 1976), by permission of the author.
Kim Levin: "Video Art in the TV Landscape: Notes on Southern California." Printed by permission of the author.
Les Levine: "One-Gun Video Art." Printed by permission of the author.
Richard Lorber: "Epistemological TV." Revised version of original article published in Art Journal, 34, no. 2 (Winter 1974/75). Reprinted by permission of the author.

Stuart Marshall: "Video Art, the Imaginary and the *Parole Vide.*" Revised version of original article published in *Studio International,* 191, no. 981 (May–June 1976). Reprinted by permission of the author.

Nam June Paik with Charlotte Moorman: "Videa, Vidiot, Videology." Parts of this material were originally printed in *Fluxus* (1964), in the Everson Museum of Art (Syracuse, New York) catalogue *Videa 'n' Videology 1959–1973,* and in *DOMUS* (1976). Reprinted by permission of Nam June Paik.

David Ross: "A Provisional Overview of Artists' Television in the U.S." Reprinted from *Studio International,* 191, no. 981 (May–June 1976), by permission of the author and editor.

Robert Stefanotty: "Kissing the Unique Object Good-bye." Revised version of original article published in *Art-Rite,* no. 7 (Autumn 1974). Reprinted by permission of Robert Stefanotty and *Art-Rite.*

Judith Van Baron: "A Means Toward an End." Printed by permission of the author.

Ron Whyte: "Sign-off Devotional (Meditation and Prayer)." Printed by permission of the author.

Ingrid Wiegand: "Videospace: Varieties of the Video Installation." Printed by permission of the author.

For
Charlotte and Paik

Acknowledgments:

For their help in preparation of this book I thank Douglas Davis, Les Levine, Charlotte Moorman and Nam June Paik. For permission to reprint material I thank Richard Kostelanetz, Rosalind Krauss and Eric Kroll.

CONTENTS

LIST OF ILLUSTRATIONS

INTRODUCTION

I: WHAT IS VIDEO ART?

What is video art? How does it differ from commercial television? Is video art linked to such traditional art forms as painting and sculpture? Is it a totally new phenomenon? What are the aims of video artists? How does one learn to make video artworks? What kind of equipment is needed? When did video art first appear and where is it going?

These are some of the questions dealt with in the essays printed in this book. However, the first question, "What is video art?," is, perhaps, almost impossible to answer. It is not sufficient to say that, as a new art form, video has attracted the imaginations of many artists closely identified with the fine arts. Nor is it enough to point out that many professionals have come to the field of video art from such disciplines as cinema, literature, education, and even commercial television.

Rather than begin with a comprehensive definition of video art, it may be wiser for the student to investigate the field in bits and pieces. In so doing we first become aware that art video, although sharing the general technology of commercial television, deliberately rejects many of its basic rules and principles. David Antin has written "At first glance artist's video seems to be defined by the total absence of any of the features that define television."[1] And Les Levine, in his essay "One-Gun Video Art" explains why most video artists don't make video tapes like real TV: "[T]hey simply don't want to." "[Video artists] are trying to use TV to express art ideas instead of simply to sell products."

Levine goes on to explain the problems faced by video artists, some of which have helped determine their particular approach. In general video artists do not have access to unlimited funding. Some

[1] David Antin, "Video, The Distinctive Features of the Medium," reprinted from the catalogue *Video Art*, Institute of Contemporary Art, Philadelphia, Pennsylvania, 1975, p. 63.

lack the complex video equipment available to commercial and educational broadcasters. However, as long as the video artist demands autonomy, he can probably expect to have to get along with relatively simple equipment, modest funding, and limited exposure. Is it worth it? We think it is. As Levine points out, "Many of the ideas in artists' video tapes are far more interesting than broadcast TV."

This is so for reasons that are fairly obvious. For example, although it is not entirely out of the question, artists do not now create video tapes for commercial exploitation or to create propaganda. Artists are not slaves to the public ratings. Nor must they make works that are entertaining. Instead, the reader will discover that many of the artists discussed in this volume have turned to video as a way of introducing advanced ideas that touch upon such subjects as visual perception in communication, criticism and aesthetics, and the potential of new electronic technologies.

In what ways can video as an art form stimulate intellectual inquiry? How can video art improve general aesthetic awareness? Can art video provide sensual and emotional enrichment? What are the qualities of broadcast video that deserve to be explored? In what ways can such exploration lead to the development of new visual principles and expand the potential of visual learning?

In order to provide answers for these and many other questions, a large number of artists trained in such visual media as painting, sculpture, printmaking, and performance have turned to video. They have discovered ways in which the television format can complement their ideas and lead to new discoveries. They have invented new ways of telling stories, creating pictures, and probing concepts that create a visual language unique to the morphology of video. In so doing they fall mainly into two categories: those producing video tapes and those producing so-called installation video. The latter are works combining tapes and the apparatus of television and are usually presented at art galleries and museums. Of installation video, Ingrid Wiegand has written: ". . . if an artist wants to get his work shown in a respected situation, the chances are about three times better if he works in terms of the installation piece." The video installation piece usually possesses distinct properties; however, it is essentially sculpture.

One artist who has presented installation video works is Douglas Davis. In attempting to identify the qualities that he feels are im-

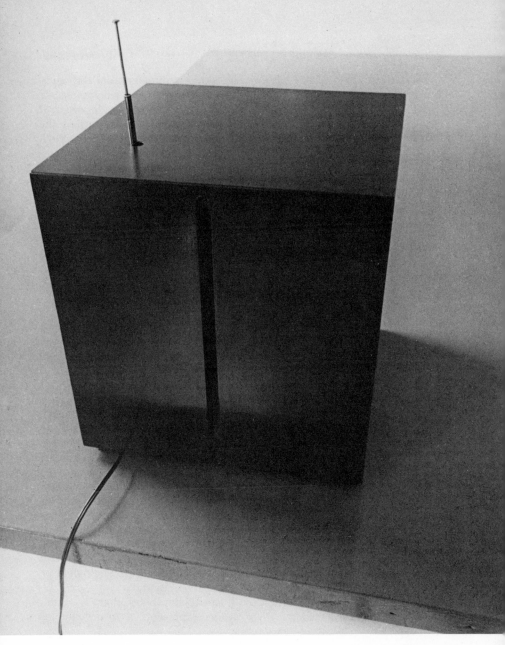

Douglas Davis: *Images from the Present Tense III (for G.B.)*. 1975.
Working television set tuned to nonbroadcast, mylar and mirror, enclosed
in Formica box. Photograph: Jimmy de Sana.

portant in video, Davis has emphasized an appreciation of the negative aspects of video. One of his installation works consisted simply of a video monitor (television set) faced against the wall, where it blared away with no audience. In another instance he buried the video monitor, and in another he secreted it under a tarpaulin. Such works are consistent with other art realizations by numerous contemporary artists, who have discovered that one way to understand the communicative properties of a medium is to challenge the very properties themselves.

According to Davis, "By turning against something, or someone, we force out of it attributes that might never otherwise have appeared." As far as television is concerned, Davis writes, "The greatest honor we can pay television is to reject it."

II. IDEAS IN VIDEO ART

In order to present a reasonably broad and penetrating view of new video art, it is not only necessary to illustrate the positive discoveries and innovations but to include material dealing with some of the problems and dangers involved. Thus Kim Levin warns that, although commercial television is the model for many artists, it ". . . may not be the ideal model."

In a similar vein Stuart Marshall believes that, in general, ". . . the video artist ends up talking to himself." Video art, he notes, ". . . is in a state of malaise . . . for a variety of reasons."

On the other hand there are a number of ideas that seem to be firmly established and some of these have formed the basis for the new video aesthetic. The concept of *narcissism*, for example, is discussed by several contributors to this book. Rosalind Krauss sums up the phenomenon when she suggests that "The medium of video is narcissism . . ." The idea implies that video, unlike other art forms, is not identifiable through its objective material (that is, its machinery) because its purpose is not to alter that machinery. The prime artistic motivation of video is to manipulate psychological or human factors. These constitute video subject matter.

Mona Da Vinci, in order to illustrate her point that ". . . the polymorphism of video artists' works represents a resurgence of

polytheism, based on the plurality inherent in a psychological world view," draws a parallel between Narcissus and Christ.

Another characteristic of video, one commonly regarded as a major quality that has shaped the development of video art, is that of *immediacy*. What this means, simply, is that video is an "instantaneous" medium. What is being created on the video recorder is immediately, in fact, *simultaneously* visible on the screen of the monitor.

The complexities and problems introduced by this kind of instant realization have become the subject matter, to a greater or lesser degree, for numerous video artists. In her article relating video art to the Latin scriptures, Vicky Alliata is not entirely joking. She suggests that Saint Veronica be appointed the patron saint of TV because ". . . the action of impressing and consequently developing, that enabled the Holy Veronica to capture the Image is . . . a persisting characteristic of the more advanced technology of . . . television." In particular it is the recent video device known as the advent system, enabling one to project video images onto a larger screen, that proves ". . . pertinent to Saint Veronica's domain."

A third concept equally crucial to the emerging form of video art seems to have been identified. It deals with the "participation," or at least relation, of the viewer. At first glance it may seem that, of all media, television is the most impersonal and the most public. However, Douglas Davis writes, "Television speaks to one mind." Elsewhere in this book Lynn Hershman emphasizes the essentially private nature of video viewing as something that directly affects the content and material of video. "Television appeals to the quiet intimacy of one's home," she writes. "Sitting relaxed in a comfortable chair and perhaps sipping a beer are part of the properties."

III: VARIETY OF APPROACHES

We do not claim that the essays, criticisms, and pictures in this book offer a comprehensive view of current art activity in video. Art activity in video spans a very wide area and involves a great variety of disciplines, approaches, and interpretations. There is a surprising quantity of art video being produced in American and Western

Europe, and any attempt to catalogue the entire field and discuss in depth the ideas currently being explored would necessitate several volumes.

Instead, we have selected a number of essays that illuminate some of the broad aesthetic concepts introduced by some of the best artists working in the field. We offer the reader this selection of the best theoretical, critical, and pragmatic documents written for and about new video with the hope that it will lead to an appreciation of the complexity, the energy, and the potential of this new, yet in some ways very traditional, art form.

A good artwork, whether it be a painting, a conceptual proposal, or a video work, is clearly recognizable. Yet the precise qualities that make the work good, interesting, and important are not easily identified. Partially this is because video is a new art form involving unfamiliar technology. Mona Da Vinci points out, in her essay "Video: The Art of Observable Dreams," that sometimes one must approach video through a system of intuitive linkups and connections that ". . . defy traditional structures and methods of critical analysis."

"Why so?," one may ask. The first reason is that if video is truly a new form it must, to a greater or lesser degree, reintroduce on its own terms qualities and principles that are timeless and universal. At the same time it must remain true to the special qualities that differentiate video from other forms. Otherwise, one might wonder, why video at all?

Thus a great many of the critical and theoretical writings pertaining to art video reflect the need to identify the medium as distinct from other communicative forms. Video possesses its own qualities and characteristics, even though many of these are not immediately apparent. Such new qualities continue to emerge as we increase our efforts to understand the form. In order to determine what video art is and what it is not many writers and thinkers have found it useful to compare it to established art forms, as well as to the new forms that have appeared during this century.

For example, Mona Da Vinci likens video art to mosaic art of the Byzantine period. And Michael Benedikt argues that the poets Wordsworth and Coleridge, although not exactly the inventors of the Portapak, advanced in their poetry an ". . . aesthetic of immediacy . . . in harmony with [video]."

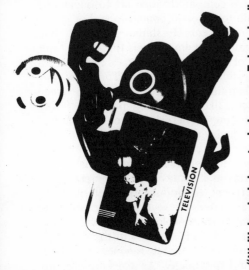

Courtesy The American Telephone and Telegraph Company

Several critics and artists have compared video art to books and printed material and have come to different conclusions. For example, both Richard Kostelanetz and Lynn Hershman point out similarities between printing and video. Hershman feels that video tape, while introducing a new way of producing images, ". . . is an extension of . . . print." And Kostelanetz notes that "The video medium itself is closer to books than film because the television screen is small and perceptually distant, like the printed page . . ." Kim Levin, however, takes another view: "There is a peculiar relationship between the book and television: Television has made the written word obsolete."

Other contributors to this book discuss the influence on the emerging video aesthetic of such forms as cinema, TV commercials, and psychoanalysis, all relatively recent disciplines themselves. Likewise, some newer art forms are cited by several contributors as bearing considerable impact upon the development of video. Les Levine argues that, in some ways, video is superior to the theatrical arts. "In the theatrical situation . . . ," writes Levine, "you have a grid of media between you and the image." As a result, "The appearance is not firsthand. So you will discount believability."

The precedents and technology of television are recognized also as having an important bearing on video art, including such devices as the relatively simple, cheap Portapak (sometimes credited with having made video art possible) and the sophisticated, expensive Special-Effects Generator (SEG).

Lastly, we should not dismiss a broad variety of subject areas that, in one way or another, seem to offer ideas and clues that will aid our understanding of video and give us some idea of its potential. Nam June Paik, perhaps the most important theorist in video art, feels that an important component of video is nothing less than global peace. Kim Levin cites the Southern California commercial landscape as a factor dominating some video art. And Vicky Alliata and Mona Da Vinci claim that God is involved. By way of corroboration we present, as the final piece in this book, the text for a "Sermonette"; this art video script is based upon the structure of the nightly prayer common to commercial television.

What all this seems to imply is that those who bring with them a background in the fine arts will feel very much at home. Similarly those who are versed in other fields, such as psychology, sociology,

cinema, and even the physical and natural sciences, will find their expertise suitable for intelligent explorations within this new medium.

Thus practically anybody can work in video, and video offers a fertile format for effective communication in all areas. With a full understanding of video we may reverse Marshall McLuhan's dictum that "The Medium Is the Message." In video we may discover that the message is the message and the medium is its servant.

IV: A FORM IS BORN

In tracing the progress of video in our time we note several remarkable similarities with the early incubation of other art forms that have preceded it. Its development, beginning as a largely experimental technology in the 1930s, through its development into a practical system after World War II and a popular entertainment system in the 1950s and 1960s, is relatively rapid.

Virtually all art forms originated with a parent form. Thus painting began, perhaps, as fresco and mosaic art. And sculpture originally appeared as a form of architectural decoration. Cinema is an extension of the theatre. All these—in fact virtually all art forms— are essentially extensions of architectural form. And, in its way, so is television.

Initially, television was thought of as another form of telephone communication. It was recognized as a persona. However, unlike the telephone, it was also perceived that television might develop into a portable idiom. In fact, if television was to become an art form it would have to develop into a portable instrument, since all art forms share the characteristic of portability, to a greater or lesser extent (the telephone is not portable; there is no telephone art).

The first advertisements introducing television to the public (appearing well before television was actually available to the public) were sponsored by the Bell System. One full-page ad that appeared in the popular magazines depicted a walking telephone with legs. The telephone was carrying a sign that read: "We're bringing you television."

The earliest television sets widely marketed were big, heavy pieces of furniture. Sometimes they resembled miniature Japanese

pagodas or oriental palaces or classic temples, complete with columns and a frieze. These heavy sets, brought into the home, became, in effect, an addition to the architecture of the interior. They were placed up against the wall, where they remained. At night the lights were put out and the chairs were lined up in front of the set. It was the ritual of cinema that was being performed in the home, where, of course, it did not belong.

At that time television had not acquired its identity. It was an imitation medium and it was heavily dependent upon the social principles of architecture and cinema for its recognition. More recently, and coinciding with the emergence of video as an artistic medium, the set became portable, the viewer developed a system of viewing peculiar to television, and video began to pass from a mere, and somewhat awkward extension of architecture, to a form in its own right.

Thus firmly established, and possessing its own vocabulary features, and identification, in fact its independence, video entered the realm of aesthetic experiment. What it will become remains, at this time, uncertain. What is clear is that the technology of video is still relatively simple and in some ways promises to become more so. Therefore, it is available in a broad sense and is not as inhibiting to the experimenter as, for example, painting or printmaking or similar forms demanding considerable practice and skill.

As a readily available form, video will certainly attract its share of amateur and undisciplined intellects. Yet the medium seems to possess the qualities and even the tradition of any other established art idiom. Its directness, its relative simplicity, and its powerful effect on the viewer assure a bright, popular, and effective role for video as a contemporary art form.

GREGORY BATTCOCK

NEW
ARTISTS
VIDEO

NEGATIVE VIDEOLOGY

VICKY ALLIATA

If it is true that in fact "duas tantum res anxias optat, panem et circen-ses,"[1] *then we can assume that video falls into the latter category. Thus it is an essential of contemporary life.*

In the following essay, Vicky Alliata relates video technology to Chris-tian theology and the Latin scriptures. Elsewhere in this volume the in-separable link between light and video is discussed, thus introducing yet another connection between video and theology: "Dominus illuminatio mea."[2]

In general Alliata predicts, for better or worse, a growing dependence upon video and a growing influence of video upon everyday life. Ulti-mately one can only hope that "ex malis moribus bonae leges natae sunt."[3]

Vicky Alliata lives in Milan. Her latest publication is a book entitled In Digest: The Best of America for a Better World *(1975).*

> *Sunt quaedam mediocris, sunt mala plura, qua media hic: aliter non video.*
>
> —Martial *Epigrams 78*

As a Roman Catholic, it is of course rather disturbing to approach a matter in favor of which the Oecumenical Council has not yet pro-nounced itself—the use of "video" technology serving mostly pagan rituals and obedient to the mundane laws of profit. We are, how-ever, encouraged in our task by a recent decree of His Holiness Pope Paul VI, which, though avoiding formal covenants and de-ferring the discussion on media profligacy to times of lesser doubt-ance, dissipates nonetheless our fear of improbation.

[1] Juvenal.
[2] Ps. 27:1.
[3] Sir Edward Coke.

During the course of the revolutionary process involving Those whose sanctity of life attained an exalted station in Heaven, and who are therefore entitled in an eminent degree to the veneration of the faithful, removals and nominations have vastly modified the allotment of patronages in order to adapt criteria of canonization to modern requirements. Such is, we might well say, the case of Saint Veronica, now officially in charge of TV. The Case of the Holy Handkerchief presents, of course, more analogies to the process of photography than that of motion pictures, but the action of impressing and consequently developing, that enabled the Holy Veronica to capture the Image is, however, a persisting characteristic of the more advanced technology of cinema and television. This accounts for the choice of a rather secondary figure in the History of Christianity for the bestowing of tutelary care and official recognition to such a vital phenomenon of our time. The problem that now arises, however, is whether video tape, video synthesizer, and video art respond to the necessary requirements of Saint Veronica's advowson. As controversial as the question may seem, we do not despair to enucleate a regiminal pattern to which henceforth conform the patronships of video hardware and video software.

"*Imago est oratio demonstrans corporum aut naturam similitudinem, est formae cum forma cum quadam similitudine collatio*"[4] and is therefore to be examined both in the nature of its contents, that is, of its subject, and in its specific structure, space, duration, and so forth. The subjects of video art, or rather the images produced by video art, have proved their pertinence to the category of iterative autolatry "*cum duplicantur iteranturque verba*"[5] and are mostly concerned with their own identity and with the search for a self-contained iconography, hence excluding external interference—primarily that of the spectator—regarded as menacing to the parthenic kinesiography both of video synthesizer and of more current videotape works. Were we to adapt such a theory to the Image on the Holy Kerchief, Veronica's presence—and that of all the faithful who witnessed the miracle—would appear not only superfluous but menacing, Christ himself having to produce the linen, to impress His features, and to observe in solitude His own effigy.

But whilst "*non in effigies mutas divinum spiritum transfusum,*"

4 Turd. *Spect.* 2.4.
5 Vid. *Seq.* 9.12.

sed imaginem veram caelesti sanguine ortam, intellegere discrimen,[6] a recent device named advent system enables one to project video images onto a larger screen, with consequent cooptation of the beholder. The advent system proves, therefore, to be, regardless of its promising name, somewhat more pertinent to Saint Veronica's domain; whether now the mere passive presence of the spectator will evolve into conscious interest, or even joy of vision, depends on the decision of the artist to descend among the people and share with them the ultimate experience of creation: *"fortes creantur fortibus et bonis!"*[7]

We are, of course, aware of the fact that the use of the mass media by artists is not likely to differ from that, *ponemus,* of party bureaucrats, for whom intelligencing, that is, conveying information concerning the category, is obviously out of the question. But in this discussion of the contents of video art, it proves opportune to purposely question the basics of iterative autolatry and generative boredom such as they manifest themselves in this specific case: *"Qui cavet ne decipiatur, vix cavet; cum etiam cavet, etiam cumcavisse ratus est, saepe is cautor captus est."*[8] Images of video art, be they *kinesiographia sterilis* produced by synthesizer or *narcissitis lutulenta* expressed by video action, in spite of their speaking of themselves to themselves and hence constituting a self-contained system, attempt nonetheless to participate in yet another system, which they however systematically exclude from their visual and ideological concerns: the commercial system, *"ut excipeant benefici."*[9]

Faced with the dilemma of how to interest the uninteresting uninterested, that is, the mechanisms of capitalist accumulation, video artists sought for the advice of a competing patron, Saint Galeria, who befittingly suggested that they maintain autolatry as far as contents were concerned and alter the structure in order to adjust video art to the law of diminishing returns. A quality of the tape being quasi-infinite reproduction, *"inde usque repetens, hoc video,"*[10]

[6] Origen or. 4.10. Cf. Aug. Friedrich Pott, 2d and greatly enlarged ed. (Lemgo, 1833).
[7] Asin. *Op. Omn.* 28.29.
[8] Plautus *Bacchides.* 4.4.57.
[9] Priap. *Frag.* 8.11.
[10] Turd. *Praes. Her.* 15.19. Cf. Facciolati e Forcellini, *Lexicon Torius Latinitatis,* new ed. by Prof. F. Corradini, Padua, 1859–78: A–Phoenix.

it contrasted with the principles of rarity *"unius esse negotium Dei,"*[11] as well as with the purpose of nondiffusion of contents. More copies of one tape meant a growing menace of public defloration, the increasing impossibility of debarring lay observers, and decreasing uniquity, hence dwindling value. Moreover, the possibility of erasure and reuse of the tape—especially if linked to generative boredom—seriously endangered artistic eternity *"quia nec initium nec finem habet haec dicit excelsa et sublimis."*[12]

Saint Galeria's iconoclastic device, limiting the diffusion of video images to a very restricted amount of the faithful, and her appropriation of copyrights of limited and signed editions, in obvious contrast to Saint Veronica's right of patronage, raise delicate questions of heretical behavior. Though we are not entitled to definite utterances, a mere glance at the history of art, which we may well define as the visual history of religion, proves reproduction to be one of the fundamental stratagems to enhance faith. Major Events of the Bible, Saints, Prophets, and other Leaders, Parables, and Miracles gave Art a right to Eternity whilst proving the generative excitement of Religion. Not only painting and sculpture but also modern inventions such as photos, posters, and slides were used to promulgate the benefits of holy images, which entered the life of the people to such an extent as to become indispensable. Such will undoubtably not be the case of video art, its restrictive greediness banishing it forever from everyday life, its sterile autolatry entangling it in coils of boredom, its lust for rarity dragging it into the marshes of castration. For all her benevolence, we fear Saint Veronica may not wish to bestow her patronship on a decayed product *"omnium mortalium atque divinium perditissimus,"*[13] for lost causes are righteously espoused for the sake of the many, never for the sake of the few.

[11] Aldh. *Ep.* 1.30.
[12] Cunt. *Pudic.* 1.
[13] Saint Augustine, *De Civitate Dei* 47.12. Cf Franciscus Umpfenbach, ed. Berlin, 1870.

POETRY AND VIDEO TAPE: A SUGGESTION

MICHAEL BENEDIKT

The striving for spontaneity has been recognized as an important goal for modern poetry. In this brief essay Michael Benedikt, who is himself a poet, discusses this idea and draws an analogy between spontaneity in poetry and a type of flexibility indigenous to the simpler video systems.

Calling our attention to such a parallel helps to demonstrate once again the interrelationship between the new video form and the traditional arts. Elsewhere in this volume the relationships between video and dance and video and architecture are pointed out. And the interaction between video forms and the broad social sciences is obvious.

Michael Benedikt has published several books of poetry, including, most recently, Night Cries *(1976). He is poetry editor of* The Paris Review.

If not quite since the year one, certainly since the early nineteenth and twentieth centuries, poets have been focusing on the idea of bringing spontaneity to their work. In the so-called modern period this has become, in general, a key value, against which others must be measured. Most often, this concern has manifested itself in terms of an interest in creating a poetry with a more direct, immediate, and lifelike language and diction.

Conventionally, the term *romantic* has been used to refer to the work of some of the pioneers in poetry in this spontaneous dictional direction. But the term is misleading, and it has always been. As in the novel, in which such a quintessential nineteenth-century writer as Flaubert provoked an immediate critical controversy about whether his work was more romantic or more realistic; and as in painting, in which such a major figure as Courbet is still legitimately

7

discussed in terms of whether he belongs more in the romantic or in the realistic basket, the term *romantic* is loose and imprecise. Outside of these examples, too, the concerns of romanticism often turn out to be not so romantic at all, but instead quite the opposite; and, in contemporary terms, apposite.

The relationship of romanticism to realism is real indeed. Romanticism arose, of course, as a way of breaking through a cumbersome eighteenth-century formalism, as a way of obviating the necessity to compose such characteristically massive eighteenth-century utterances as Alexander Pope's decorous, metered, rhymed, and verbally stilted "Essay on Man." Romanticism in poetry, which is generally considered to be the watershed period of modern poetry, had as its hardheaded core the idea that the nature of reality is not calculated or preconceived in the eighteenth-century manner (which is seen by most romantics as quaint in itself; and not classical, as it had claimed, at all) but rather is extravagant, outrageous, and spontaneous. To attend to that possibility, is, they felt, in fact to be realistic.

Few modern poets have been as concerned with spontaneity as a key aesthetic value as were those pioneer romantics and keystones of modern poetry Wordsworth and Coleridge. In Wordsworth's preface to *Lyrical Ballads* (1849; the book itself was originally published in 1798), written in collaboration with Coleridge, the former says (in a diction as curiously labored as that of his best poetry is not): "It was published as an experiment, which I hoped, might be of some use to ascertain, how far, by fitting to metrical arrangement a selection of real language of men in a state of vivid sensation, that sort of pleasure and that quantity of pleasure may be imparted, which a Poet may rationally endeavor to impart."

Rational? Endeavor? Surely these are among the most surprisingly deliberate terms a "romantic" poet might have used. The language verges on the language of research; the tone of the statement is scientific. Elsewhere, Wordsworth captures his vision of the "real" more succinctly, saying simply: "I have wished to keep the reader in the company of flesh and blood."

Why this determination? The desire to throw aside earlier (in this case, eighteenth-century) concepts of decorousness always has, of course, many sources. In this case, at a time of great social and political changes, and sometimes literal revolution, the essential

ideas of the eighteenth century no longer seemed to hold true and certainly were exhausted in aesthetic terms. A new idea of people at their fullest—and of people reflecting that fullness—was being born. In the case of these two pioneer romantics, the interest was additionally and positively confirmed by the readings in the new science of psychology that Wordsworth and Coleridge had been doing. It was not precisely what we today call depth psychology, but it did suggest that in order to reflect the full psychological nature of men and women poetry, on the technical level, had to speak the truth in a more open, flexible diction, and perhaps, ultimately, in form.

One could tot up quite a list of poets since the Lake Country Wanderers (which sounds suspiciously to me like the name of a contemporary rock group) who have been determined to get spontaneity into poetry, through the use of an undecorous or "open" diction. Twentieth-century developments such as the idea of "free" verse in the early part of this century (although beginning with Whitman in the late nineteenth century) link the past to the present. Certainly an echoing of the eighteenth-/nineteenth-century conflict exists today in the efforts of poets of the 1960s and 1970s to get away from the formalism of the critically dominated poetry of the conservative 1940s and 1950s. The convulsion of change begins with the beats in the later 1950s, with Allen Ginsberg as characteristic prophet, and continues through the 1960s, first through the loosening up of the styles in the 1960s of the "major young poets" who continued to write after the 1950s: that is, in the work of such accepted contemporary masters of American poetry as James Wright, Louis Simpson, W. S. Merwin, Robert Bly, and Donald Hall. It is no accident that one of the most characteristic as well as successful of recent anthologies of poetry of the 1960s direction is entitled *Open Poetry*[1] and is subtitled *Recent American Poetry in Open Forms*. And it is no accident that its editors note in their preface that an earlier, seriously considered title was *Organic Poetry* (a concern expressed by several contributors in essays accompanying their poems, but most notably by Denise Levertov in her statement called "On Organic Form"). In fact, the term *organic* is one frequently used in his criticism by Coleridge, whose critical and prophetic

[1] Stephen Berg and Robert Mezey, eds. (Indianapolis, Ind.: Bobbs-Merrill, 1969).

abilities enabled him to see that concomitant to an "open" diction
is an open, improvised, and spontaneous poetic structure.

How, then, does this relate to video tape? The analogy seems to me
not at all farfetched. As modern poets desire a medium of flexibility
to work with—one obviating old cumbersomeness—the contempo-
rary video maker must rejoice in the flexibility of his instrument.
Each two-person team (the recommended number for "maximum"
video efficiency and "completeness") is in effect an entire and
instant television studio, or film studio. Wordsworth and Coleridge
and the poets who followed them were not, to be sure, the inventors
of the Portapak; but surely their aesthetic of immediacy is in har-
mony with it. Immediate feedback in response to contemporary
language, as a way of responding to the larger picture of contempo-
rary reality, has as its analogy the instant checking-back or replay
possibilities of videotape equipment. Also, modern poetry is tradi-
tionally accused of not having been "edited" sufficiently, as if its
style were some kind of accident; there is an analogy, I think, to the
"difficulty" of editing video tape. It is a challenge that, I believe,
is one video makers at present must welcome, just as a certain
"unedited" quality is positively attractive to most contemporary
poets, in a technically and philosophically explorative time.

The commitment seems to me to involve not only aesthetic style
but a certain moral scrupulousness with respect to "telling the whole
truth" about experience. How many video tapes haven't we all seen
that concern themselves with immediate events and responses to
them, in the sense of the idea of conveying "men [and women
equally] in a state of vivid sensation"? And sometimes, even, in the
throes of a "romantic" excess, or else (its corollary) an extreme,
extravagant, and total funk? As the rejection of a cumbersome
formalism is the subject matter of much modern poetic diction and
form, immediate feedback is not only the style but the subject matter
of the image in video.

VIDEO: THE ART
OF OBSERVABLE DREAMS

MONA DA VINCI

In this essay Mona da Vinci draws a parallel between art developments in the fourteenth century and the post–World War II emergence of video art. She refers to the video art of Vito Acconci, Robert Morris, Dennis Oppenheim, and Nam June Paik, claiming that it is a "mental rather than a physical process" that makes video art distinctly different from other art forms.

Video, according to da Vinci, is potentially a more satisfying and complete art medium because it is free of the usual "object" and because it calls for a new emphasis on "connectedness, communication, integers, and vectors." These, the author notes, offer the opportunity for exploitation of the "artist's full creative powers."

As to art criticism, the author concludes that "video art may even supersede the necessity for art criticism as we currently know it." The reason for this lies in the very nature of video and its great sensitivity to nuance and detail, which may provide artists "the ultimate opportunity to develop an autonomous, self-critical sense of their own work."

Mona da Vinci is art critic for the Soho Weekly News *and has contributed articles on art criticism to several journals.*

Video miniaturizes our view of the world. Experiencing *Gulliver's Travels* via an electronic screen or monitor, we view the island inhabited by our human complexes in Lilliputian forms. These psychological mirror images are based on qualitative fields of high probability, according to the theories of modern atomic physics. The expectation values for synchronistic connections are a built-in

11

guarantee of the video medium. Time automatically becomes more questionable than space. Video is "arrowless" time, where micro-events recorded on tape could have happened backward and forward in a collapsed space.

Back to Byzantium. Collapsed space is flat and shows no depth but a nonreceding, infinite background. Figures and ornaments are all parallel to the picture plane. Mosaic patterns and formal, frontal, stylized presentations reflect very strange and rigid tensions, designed to strike terror into the viewer. Contemporary artists' use of video may be comparable to the fourteenth-century painting done by the Black Death artists in Florence and Siena after the plague had decimated half the population.

In this century two world wars culminated with the dropping of two atom bombs on Nagasaki and Hiroshima in 1945. The religious fear and trembling in the wake of the bubonic plague was replaced by the literal population explosion, brought about by the Black Death of modern atomic warfare. Television emerged as the revolutionary medium to cool down the masses immediately following the end of World War II.

The pragmatism that enabled U.S. physicists to produce and actually use such a terrible weapon on Japan shocked the world. Even the German physicists were horrified that their colleagues in America had done so little to make public the evil consequences that would result from dropping the bomb. As if to compensate for the inhumanity of science and politics in world events, the United States also produced its own Black Death artists by midcentury.

Jackson Pollock, Barnett Newman, Ad Reinhardt, Franz Kline, and Willem de Kooning mirrored in their paintings the flux and disintegration to signal the millennium's demise. Civilization had been stripped down to black and white, the existential either/or. The split atom had fissioned art into the split-frame concept, or the overall chaos of an indifferent universe.

Throughout the 1960s artists everywhere created, actively and passively, enough intellectual and aesthetic riddles amid the deluge of cataclysmic upsets to weather the ground-breaking transitions begun in that decade, and to carry us through as we ready ourselves to enter the new Platonic month, which will last approximately two thousand years.

The balance. Using an act of will based upon being driven or

having the urge, artists turned on to video as a new art form during the Vietnam war. Marshall McLuhan had cleverly informed these artists about the new media by letting them know in print that the moment for the application of the real art in futurist theories and inventions was now at hand. McLuhan's disguised message that technology and electronic media had finally caught up with the dreams and desires of the early Italian futurists is wisely hidden between his lines.

Only artists and writers who are attuned to the divine speed of light and electromagnetic waves can begin to perceive and apply themselves to the futurist aesthetic being configurated in this dawn of a new age. Obviously, most video artists aren't consciously aware of video's potential to transmute all the futurist manifestos and polemical writings into the dynamic, tactile, electronic, participational art that Marinetti, Boccioni, Carrà, Severini, Russolo, Balla, and Prampolini had proclaimed and foresaw prior to 1920.

Because video is a completely new and still uncharted art form, I prefer to discuss the nature of the medium and the works of key video artists through intuitive linkups and connections, which will no doubt defy traditional structures and methods of critical analysis. After all, what's the sense of putting new wine into old bottles?

At this point, the following quote from C. G. Jung's *Aion: Researches into the Phenomenology of the Self* captures the full scope of what kind of matters I think video artists are setting into motion:

> The present age must come to terms drastically with the facts as they are, with the absolute opposition that is not only tearing the world asunder politically but has planted a schism in the human heart. We need to find our way back to the original, living spirit which, because of its ambivalence, is also a mediator and uniter of opposites, an idea that preoccupied the alchemists for many centuries.
>
> If, as seems probable, the aeon of the fishes is ruled by the archetypal motif of the hostile brothers, then the approach of the next Platonic month, namely Aquarius, will constellate the problem of the union of opposites. It will then no longer be possible to write off evil as the mere privation of good; its real existence will have to be recognized. This problem can be solved neither by philosophy, nor

by economics, nor by politics, but only by the individual human be-
ing, via his experience of the living spirit.[1]

If there is meaning, there is order. Video. Light through a non-
dimensional screen, blurred edges to disrupt the frame concept, to
gain an atmospheric perspective on events. Synthesize fact and idea
at once by analogy. Fusion of contradictory forces, where opposites
are not dualisms, where the ambivalence or conflict is implicit, not
explicit. A double nature.

The video monitor is never blank or empty but, like the pupil of
the eye (when opened), reflects the images within the field of
vision. According to T. Gomperz, the reflection in the pupil of the
eye vanishes at the point of death. What is death? Energy without
a source. Source without an energy.

Performance. Mick Jagger in drag. The concept at the heart of
the process: the decapitation of the concept in a concerted effort
toward infrarealism. The denigrating image is black humor calumni-
ating the object. Distortions of the live, human body parody modern
art. The subject is correlative to a body/psyche unit. Finished art is
the ludicrous behavior.

Transferences in performances: from life to stage, from one
medium to another. Performance needs a gradient equal to the
energy expended in order not to dissipate the charge or the effect.
Being true to the medium.

Vito Acconci in the role of antagonist. Creative masturbation as
self-generative, a closed-circuit autonomy, a self-rolling wheel, an
act of ouroboric centroversion. Shock the seismic public. See if it's
still possible. "There is no reason," Acconci's way of *leveling* with
the gallery situation, via quadraphonic audio traveling at the speed
of sound through the Sonnabend gallery space. Configurate within
art, strictly human force fields of experience. Carry on a pretense,
a subsong. Endurance tests strengthen the will. Becoming independ-
ent of the body, mind over matter. The borderline conception.

A message to the medium. Acconci as trickster. Breaking down
dogmatic interiors. Nemesis again, the eternal plague of the poet-
writer and the painter-artist vying with each other about which art

[1] *Collected Works*, vol. 9, pt. 2, trans. R. F. C. Hull, Bollingen Series 20,
2d ed. (Princeton, N.J.: Princeton University Press, 1968), pp. 86–87.

is the divine, the sublime, the highest form yet conceived to follow the example of God's creation. Art without a backbone, or to put it more gently, torn between color and words.

The trickster creates a critical impasse. Art banished to the "notions" department. Seeing through the tricks of the trade by generalizations, oversimplifying, detecting the fixed patterns step-by-step, point-by-point, until there's nothing sacred left. The methodological secret: Ferocious Satire. The guiding premise: If you underestimate the power of art (the enemy), it's then possible to overestimate your ability to conduct a one-man guerrilla war against that power.

Underneath it all is Acconci's enacted xenophobia. According to Ovid, rather than Freud, Narcissus rejected the nymph, Echo, who loved him. Actually, he spurned Echo's body but not her voice, which repeated his own words back to him right after he spoke them. Narcissus was quite willing to pursue Echo as long as she remained a disembodied, audible voice following him with his spoken words transformed into Echo's passionate inflections. Mary Magdalene suffered a fate similar to Echo's when she reached out to touch Jesus Christ after the resurrection. Check Giotto's *"Noli me tangere"* scene in the Arena Chapel frescoes.

The parallel between Narcissus and Christ carried one step further. Narcissus fell in love with his own image reflected in the pool, never realizing it was himself as a disembodied visage that he longed to embrace. Christ simply said, "Love thy neighbor as you love yourself."

What does all this have to do with video art? The power of the word *video*, to see God, may yield a specific content that will restore new meaning to the illuminated image. "In the beginning was the word, and the word was . . ." Who knows? Maybe the polymorphism of video artists' works represents a resurgence of polytheism, based on the plurality inherent in a psychological world view. Psychological space is nonphysical and nonspatial. Mental images do not occupy space or have weight and, like dreams, have a relatively low image definition. Watching video may be a new form of media day or night dreaming without having to go to sleep. Certain artists would automatically be attracted to the video medium because film's high image definition and painting's physicality were

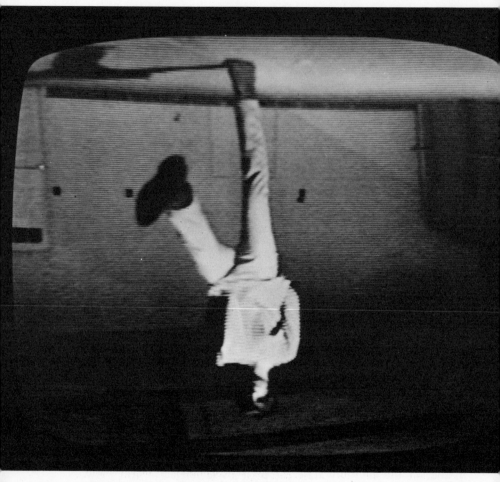

Bruce Nauman: *Revolving Upside Down*. 1969. Black & white, with
sound, 55 mins. Courtesy Castelli-Sonnabend Tapes and Films, New
York. Photograph: Gianfranco Gorgoni.

never as convincing as literary images for the depiction of the dynamics of that epiphenomenal region called psychological life space.

Visual artists seem to have more difficulty adapting their art to the intrinsic properties of video than the video artists who were former writers (Acconci), musicians (Nam June Paik), or mathematicians (Bruce Nauman). Writing, music, and mathematics are far more congruent disciplines, both in concept and actualization, to the discontinuous and indirect symbolizing processes activated via the instantaneous electronic feedback of the video medium. Matter and energy become interchangeable forces, akin to life processes by video analogies and anomalies, causing video art to appear fundamentally and primarily living.

Video art takes shape and form through a process of an inner unification of affinities, where elemental effects are forced together into observable facts and derived behavior. The text, the score, or the formula are applied, coordinated, and manifested in the dynamic movements, tendencies, and forces being topologized and recorded on video tape by artists. Video successfully bypasses object art, for a new emphasis on connectedness, communication, integers, and vectors, that could potentially lead to a more satisfying and complete synthesis of the artist's full creative powers. Video promises the possibility of providing the intervening conceptual means for the artist to dispense with the artificial or the artifice in art. The medium's capacity for immediacy symbolizes "the missing link," that may fill the gap between art and life experience to the contemporary artist. The developmental phase becomes a thing of the past in the video artist's creative output.

Video art may even supersede the necessity for art criticism as we currently know it. The nature of the medium, its extreme sensitivity, for instance, to barely perceptible nuances and affects, offers video artists the ultimate opportunity to develop an autonomous, self-critical sense of their own work. If artists learn to develop their own powers of self-criticism, they will rely much less on outside criticism to determine the development of their art. Video gives the artist a viable mediator that is almost therapeutic in encouraging self-analysis or active imagination.

The artist is forced to withdraw psychological and physical projections in video art. Even projected video can be seen through.

Both the viewer and the video artist are always in an indirect relationship. The viewer participates as an autonomous agent in real space, observing the actions and experiences of the artist transformed into the electronic space of video. Electronic space can only serve a psychological or intellectual function, being made observable by the video artist for one's own self-examination. This withdrawal of projections back into the self works both ways, for the viewer as well as the video artist. Escape into the object or the other is rendered impossible in physical terms.

Artists who are primarily painters or sculptors such as Dennis Oppenheim, Robert Morris, Lynda Benglis, and Richard Serra seem less likely to continue working in video as a totally self-contained art medium. As visual artists, they sooner or later retreated back into the "object," used either in conjunction with their video tapes as part of an installation exhibit or as a separate and temporary experimental phase apart from the mainstream of their work.

Morris has admitted he found the video medium much too tedious and time-consuming. Oppenheim is fully aware of the importance of the literary aspects of Acconci's video tapes and how the work is greatly enhanced by a strong literary sensibility. Whether Oppenheim and Acconci could successfully collaborate as equals in a video work remains problematic to both artists for many reasons, although they have considered the possibility of working together. Documentational or narrative video are more amenable to collaborative video work among artists. Video tapes such as Acconci's have an acute awareness of the medium's essentially unfocused ground or space, implying that a mental rather than a physical process is what makes video distinctly different from other art forms.

The major reason that this conscious acknowledgment on the part of video artists that the medium communicates on a mental and psychological level rather than by a direct physical interaction is so important is that the ethical responsibilities of communicating on such levels cannot be ignored by the video artist. Unlike Nam June Paik, who makes no bones about his desire to captivate and capture the mass audience, which he does by appealing to the collective unconscious of the viewers, Acconci ethically and aesthetically maintains an intimate one-to-one electronic communication with a viewer. On an adult level the effect of this major difference between Paik's and Acconci's approaches to video is like the difference be-

Robert Morris: *Exchange*. 1973. Black & white, with sound, 32 mins. Courtesy Castelli-Sonnabend Tapes and Films, New York. Photograph: Gwenn Thomas.

Lynda Benglis: *Document.* 1972. Black & white, with sound, 8 mins.
Courtesy Castelli-Sonnabend Tapes and Films, New York. Photograph:
Gwenn Thomas.

Richard Serra: *TV Delivers People*. 1973. Color, with sound, 6 mins.
Courtesy Castelli-Sonnabend Tapes and Films, New York.

Still from *Nam June Paik, Edited for TV*. 1976. Color, 30 mins. Courtesy WNET/13. Photograph: Eric Kroll.

tween watching television commercials for children's toys at Christmastime and watching *Mister Rogers*.

Paik and Fluxus never really parted ways, which is a far cry from Acconci laying bare his soul to himself or that mysterious Other, the viewer "out there." In Paik's video works, I see an undifferentiated region of chaos, or the void; whereas in Acconci's video works, there's usually a hope of union in the future or an implied resolution hinted at in the continuing process.

THE END OF VIDEO:
WHITE VAPOR

DOUGLAS DAVIS

*The importance and vitality of what video is can perhaps be determined
by a thorough examination of what video is not. The author of this specu-
lative, theoretical article about the meaning and aesthetic of video art has
himself produced a number of video works that, according to some critics,
are so thoroughly negative they do not really fit within the spectrum of
video art.*

*Some of Douglas Davis's own works are discussed in the following arti-
cle, including one in which Davis simply turned the video monitor (the
set) face against the wall. In another instance Davis buried the video
monitor. And in another he secured it under a tarpaulin. On yet another
occasion he smashed a video camera through the screen of a television set.*

*Numerous contemporary artists have discovered that one way to under-
stand the most effective communicative properties of a medium is to chal-
lenge the very properties themselves. Such artists as Man Ray, Marcel
Duchamp, Jackson Pollock, Jean Tinguely, Piero Manzoni, and numerous
conceptual artists have offered provocations that seem to negate the very
existence of their art. Davis is determined to follow this route in his ap-
proach to video; therein lies his uniqueness.*

*As he himself points out in this article, Davis is involved in a general
renunciation and rejection of the video medium. "By turning against some-
thing, or someone, we force out of it attributes that might never otherwise
have appeared," he writes.*

Douglas Davis, besides being a video artist, is art critic for Newsweek
magazine.

Zone of white vapor—programmed spectrum—"the dead are living
electric units phoned away—supersonic—they merge on crystal enemy

in blue heat their pictures spell out Piccadilly on the Metallic Voice-
Writer & produce THE WORD°D E A T H TV°°"
 —Burroughs, Pelieu, Weissner,
 So Who Owns Death TV?

I want to begin with a very beautiful story that may be a parable.
I'm not sure whether it is true, but it ought to be. It is alive, in any
case, all over the world, for the story has been repeated to me many
times in many places. It begins at midnight in a little cable television
station in the suburbs. The station is owned and operated by one
man, like a family store or gasoline station. That night, instead of
signing off, he dollies his lone camera into his office. He sits there
in front of it for a long time, thinking what to do. Then he remem-
bers that he has to clean out his desk—something he has been delay-
ing for years. So he begins, starting with the top drawer. Instantly
he knows he is onto a good thing. For as he rummages through the
accumulation of old pencils and parking tickets, he starts to come
upon unopened letters stashed away in the heat of the past: a few
of them—*mirabile*—contain checks! There are notes from long-lost
friends, some of them lovers from the past. The man forgets that he
is on camera: He is engaged, after all, in a rediscovery of himself.
He opens every drawer, examines every shred of paper, every object.
Some are thrown away, others are stashed in his coat pockets; a
small portion return to his drawers. When he finishes with his desk,
he attacks the old battered file cabinet next to it, bulging with maga-
zines, newspapers, bills, accounts, a half-empty bottle of whiskey.
By the time he is finished, the first rays of morning sunshine are
breaking through his window and falling on the face of the camera.
He has broadcast himself for eight hours!

The denouement of the story is that the audience loves it—a few
people had been drowsing beside their television sets, woke up to
turn it off, and saw this man emptying out his desk. They can't be-
lieve it; they watch; it grows on them, like a boring but somehow
comfortable guest; they call their friends; the word spreads quickly
around the little town served by the station. Next day the man be-
gins to get congratulatory phone calls. Later in the week, there are
letters. Somehow the news reaches one of the wire services, and his
diffident, nightlong gesture is escalated to international status. He

never repeats it, however. He returns to his humdrum work and is never heard from again.

This is a climactic story for me—and for all of us—whether true or false. More than anything else, I am fascinated that the story nowhere contains a hint of the man's motive. This is because neither the tellers nor the hearers of the tale, wherever they are, feel any need to state the motive. They know it. An analogy is the recurrent fairy tale theme (surviving in all known cultures) of the abandoned or forgotten child who is rescued by the hero in the end. Nobody questions the motives of the hero: It is *assumed* that a child in distress ought to be aided. It is also assumed in the parable that the man who opened his desk drawers on television did a good thing, perhaps even a great thing. He may be the unidentified hero of postmodern culture, if not of art.

I nominate him in any case for the prize. In order to justify that— and explain my own motive—I have to change mood abruptly. I have to turn not only to the subject of "video art" (that loathsome term) but to the time frame in which we view it and television itself. Broadly speaking, we think and act in two tenses: One is the present, where we are continually faced with obdurate existential crises. The present-tense crisis demands that we deal with facts now, on their own terms. In this sense, I am at the mercy of television-as-it-is (together with the-art-gallery-as-it-is), and so are you, as perceivers, creators, artists, critics, citizens, politicians. But we also live in a kind of future or theoretical time; our language reflects this. The very word *tomorrow* is a hopeless and optimistic idea, but there it is, affecting the way your mind works (or is it the reverse?), and highly practical action often results from this second kind of thinking. The more I work in "video"—a term that has no more meaning than *paper* or *crayon*—the more I perceive myself and others acting on this second level, *against* television-as-it-is (and the-art-gallery-as-it-is). The horrible misunderstanding of the work that results from this situation is the result of a time-crossed contradiction—of perception anchored in one tense and action taking place in another.

To say it in another way: "Video" is *not* the issue. The activity that *uses* video is not for the most part *about* video. We started, most of us, believing that television was the issue/enemy, to say nothing of art itself, but that is not where we are ending. In a minute I will begin to punctuate what I am saying now with slices of

ideas and manifestos from my quickly receding past, leading up to now. In the beginning I thought that changing television would change virtually everything else, whereas changing art was entirely a parochial matter. McLuhan had a lot to do with this delusion, as did Clement Greenberg, early postwar linguistics, and a great deal of avant-garde, postmodernist cant. Their influence faded, however, as the work itself continued, yielding its own lessons.

I grew up facing the television screen, but I didn't begin fully to think about it until I saw its backside. That happened late one night at a party, many years ago. I had danced and drunk myself into exhaustion. Lying on the floor, I watched the host wheel out his television set into the middle of the room. The people gathered in front of it. When he turned the set on, I remember first noticing the pale blue light of the screen flicker across the watching faces. Then there were the lights inside the set, glinting white yellow through the slats in the back. I was a long time watching television from the other side that night and even longer thinking about it for years afterward. When I finally made the image—installed my own backward television set in a dark gallery room—the act was almost an afterthought.

I wasn't clear about my attitude toward television then—whether I was "for" or "against" it in a simpleminded, highbrow sort of way. McLuhan always rails against the yes-no simplicity, then goes on to postulate simplifications even worse. The backward television set functions on a level beyond either McLuhan or me (in my rational mode); I hasten to add that turning the set around was an act forced *on* me: The image created me, not the reverse. The act emerged from a juxtaposition of chance events and contingencies. Remember also that when I first saw it, I was barely conscious. I must have responded to it from the right side of my brain, or at least that part of it not governed by logic. Art is one area of accepted human activity wherein that faculty is at least tolerated. So is the fairly tale, and the street story. The suburban parable strikes the same chord. You will not read about it in McLuhan's texts (in fact the story probably troubles him). It is in none of the writing about "video art" that I have seen. And you will never hear it repeated at the high-level conferences called in Europe and in America to discuss the Impact of Television upon Civilization. But it tells us more about the double-edged meaning of "video" than anything we now know.

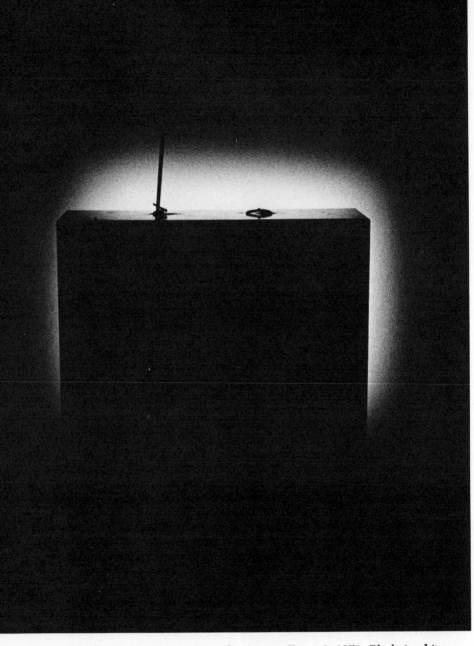

Douglas Davis: *Images from the Present Tense I*. 1971. Black & white, with sound, 30 mins. Installation Reese Palley Gallery, New York. Courtesy Nam June Paik. Photograph: Edwin Curran.

Here are some thoughts that followed the reversing of the television set. Each in its own way influenced work that I made in the early years, whether in the making of video tapes, performances, objects, or live telecasts:

The acts of conception, selection, and reproduction are equal to the first act of making. . . . Art is common, rather than individual property.

> —Statement for *Giveaway*, an event/performance, 1969

The canvas was installed in the museum the next day with documentary video tapes suspended down across its face. It is a work of art with the capacity to depict its own making. . . . Television is the eye in process.

> —"Radical Software," 1970

EXPAND SIGHT AND SITE
> —"Manifesto for a New Television," 1971

This is a real-time
 video tape.
The performance you are
 watching
has occurred
 is occurring
in real time your time
 no editing.

> —Statement for "Ten Videotape Performances,"
> Finch College Museum, New York, 1971

This represents a keenly different awareness and exploitation of time. It is neither fixed nor circular. It is progressive. It destroys static notions of art and life. No medium demands this progressive sense of time more than video, which is why—among other things—video is political in the deepest personal sense. The more fully we exploit the medium as art, the more completely we change perception. . . . At its aesthetic core video is art dematerialized. Its organic physical qualities are confined to the loop tape, the cartridge cassette, or live

broadcast through the air. Therefore the result is political and aesthetic at once: swift, intense communication, not possession.
—From "Video Obscura," *Artforum,* 1972

BURN THE MANUALS
STOP THE NAMES
The camera is a pencil.
—Manifesto exhibition at the Everson Museum,
Syracuse, New York, December 1972

The above is here to provide the context for the idea I am now trying to frame. It is a very different idea, but so different, so far away from the main idea presented above, that they in fact meet, somewhere on the edge of reverse extremes. I didn't begin to walk on television screens, smash cameras through them, and bury cameras under the ground until I reached that extreme. I took this route not out of boredom, not out of renunciation of my own past and that of my colleagues (who were equally optimistic in the early years), not out of a desire simply to change. I was learning, responding to my own images and those images I saw around me. I learned that a vital quality was missing from the entire corpus of "video art." It is summed up in this beautiful thought from Man Ray: A certain contempt for the medium you work in is essential.

NO VIDEO
NO VIDEO
NO VIDEO

AGAINST IT
IS FOR IT
—Manifesto, July 1973

This does not mean that I am *against* television, any more than Man Ray was against photography. Rather, I have learned to be against a certain conception of television, which is intimately related to a prevalent conception of art. I have become very fond of Ad Reinhardt recently. He was a man constantly engaged in his later years in the denial of painting. Certainly you remember him, talking about his all-black painting

Douglas Davis: *Burying Camera* (*The Cologne Tapes*). 1974. Black & white, with sound, 6 mins.

as the most extreme, ultimate, climactic reaction to, and negation of, the (cubist, Mondrian, Malevich, Albers, Diller) tradition of abstract art, and previous paintings of horizontal bands, vertical stripes, blobs, scumblings, bravura, brushwork, impressions, impastos, sensations, impulses, pleasures, pains, ideas, imaginings . . . meanings, forms of any traditions of pure, or impure, abstract-art traditions, my own and everyone else's.

I am feeling a little bit that way. There is much joy involved in flushing out meanings and positions imposed by external understandings (in my case, the going consensus about "video art"), as well as denying media.

I want to say a cryptic word about what is wrong with investigating and understanding media, which has, I assure you, application to formalist theories in linguistics and in painting. To investigate what is known, that is, what is empirically there, only yields more of what is known. This is a difficult thought to put into words, so please bear with me. The definition of television as a private, lonely medium—a definition that was in my mind from the start—is a case in point. No sooner is the word out of your mouth than it is seized instantly in empirical terms. Once I tried to talk about it on a network television discussion: As soon as I said it, the television professionals around me leapt on it with huzzahs, in agreement. I had gotten no further than one sentence: "Television speaks to one mind, not to a public mind."

Television speaks to one mind. Think of that! In one sentence it seems to destroy all the garbage of the past, as did Kasimir Malevich's White on White, Alexander Rodchenko's Black on Black, Ad Reinhardt's Black. Or does it? Did they? You know the answer. Objective perception never reflects anything beyond itself. To know what is there is not to know what isn't. The last way to put this cryptic thought, is as follows: The makers of television-present-tense are fully as intelligent as those who criticize it. They know what we know. Therefore. It is my task—your task—to act beyond the medium, from within ourselves.

Burying Camera At midnight in the German forest party marching with bonfires the grave is dug the camera

gently lowered into the ground on white pillow all silence
no words spoken covered with earth
 —From text for *The Cologne Tapes*, 1974

Please come to your television set place your hands against
mine, through the tips touching the screen think about
what this means
 —From text for *The Austrian Tapes*, 1974

Walk with me on your television screen touching our toes
Who is up and who is down?
 —From text for *The Florence Tapes*, 1974

TRYING TO GO INTO MY MIND
AS DEEP AS I CAN
AS FAST AS I CAN
WHILE YOU ARE WATCHING IT THINK
 —From *Studies in Myself*, 1973
LET US BRING AN END TO MEDIUMS
END ALL MEDIUMS
MAKE THE LAST PAINTING THE LAST SCULPTURE THE
 LAST PHOTOSTAT THE LAST PERFORMANCE

MAKE THE LAST VIDEO TAPE
 —From *Fragments for a New Art*
 (both video tape and book), 1975

In renunciation and rejection there is indeed a singular beauty.
By turning against something, or someone, we force out of it attrib-
utes that might never otherwise have appeared. I have a friend, a
brilliant painter, who has never received any recognition at all. Her
shows are unreviewed and her name rarely mentioned. At a certain
point in her career she renounced herself and she began to make
other people's art. Her ego is totally submerged in the works of
others (she is now engaged in remaking all of Duchamp's graphics).
Yet her hand is more visible now than ever.
 The greatest honor we can pay television is to reject it. For me,
this means literally ignoring video, and certainly the preconceptions

Douglas Davis: *Studies in Myself II*. 1973. Color, with sound, 30 mins. Courtesy Stefanotty Gallery, New York.

about what "video art" is all about. That doesn't mean that I ignore
the picture plane and the camera, any more than I ignore this paper
before me and the typewriter keys that are striking it. But I know
the words will be reset in another type and read on distant papers
at differing times and perhaps in languages that I cannot even un-
derstand. To telecast takes us even further away from physicality:
The image I sent out arrives on screens in hundreds of shapes, tuned
to any of a thousand (perhaps a million) modulations. Yet there is
an irreducible core of communication. It is in this core—and only in
this core—that art differentiates itself from entertainment, or decora-
tion. Please don't label this conviction mystical. It is no more mysti-
cal than the conviction on the other side (that art is reductively and
mindlessly physical). "Mysticism" is a code to cover up truths that
cannot be rationally understood. We don't rationally understand
how language works either, how our minds reconstruct chance
sound patterns into units of meaning in our brains. Communication
in the sense I am discussing is thus the end and the object at once,
the completion of the cycle begun (but not finished) by Duchamp,
and television-tape-object-performance is simply the language, or
the paper. It is only a means. It is not important. We should not
mourn on its grave, but dance on it with joy.

 Who owns D E A T H TV? Eight years after these bloodcur-
dling words were written (I first read them in 1967), I think I
know the answer. The little man shuffling his drawers in the suburbs
had the answer. So do we. In fact, we own D E A T H TV. We
are the guilty ones. It is our network, arranged for our own trans-
ferences and cross-linguistic exchanges. The television in our minds
(not as-it-is) takes on a complex form, sweaty, odd edged, jagged:
Can you imagine innumerable single minds telecasting to single
minds, as if television were print? I can. Not the cold, bland, silly,
stiff, and monolithic system that bestrides our lives. Know all you
wish to about that medium—its privacy of perception, its line, color,
and tone, its symbiotic link to living, moving time—and you still can-
not change it, or act in it as a human agent, until you bury it. That
man in the suburbs forgot he was "on." He behaved like a free man.
Our task now is to follow him, hat in hand, forgetting where we
began.

REFLECTIONS ON THE ELECTRIC MIRROR

LYNN HERSHMAN

Much of the urgency and inspiration for art video emanates from various types of commercial television broadcasting, including soap operas, commercials, and such popular mavericks as Mary Hartman! Mary Hartman! *In this essay Lynn Hershman identifies some of the commercial genres that may, in one way or another, have influenced artists working in video, and she relates these to specific works by such video artists as Terry Fox and Eleanor Coppola.*

Lynn Hershman is a young Californian conceptual artist who has created artworks using the spaces and properties of the Plaza and Chelsea hotels in New York. In 1976 she presented artworks of a conceptualist and surrealist nature in the windows of Bonwit Teller's department store.

The distribution of television sets in America roughly matches that of indoor plumbing. At an average of four hours per person per day brains bounce off of the edges of an oscillating screen. For more than one quarter of a century the subconscious texture of syncopated communication environments has seeped through our collective conscious, knitting our species—like Gregor Samsa in Kafka's "Metamorphosis"—into a transformed organism. Television has rechanneled our sense of time and space.

The human brain is divided into two hemispheres, left and right. Most people over twenty-five have been trained to center their thought patterns on the brain's left side, which concerns itself with proposition, reason, and linear logic. The right side of the brain controls nonsequential, nonanalytic, intuitive impulses. Television

36

has been massaging our right hemispheres, a previously ignored and somewhat atrophied segment of our physiology. And the constant stimulation of our heretofore neglected left lobe appears to have released telepathic and intuitive instincts as well as opening the valve that allows a flow between the two sides. Ideally, the two sides should work together and flow easily into each other, like the day into the night. Television encourages this interaction.

Mary Hartman! Mary Hartman! underlines the truths implicit in nonlinear patterns transformed into melodrama. With the exception of the news, it is the most modern show on television. Made up of nonsequiturs, it is a scrapbook of styles. By breaking all of the rules, it invites a strange realism that offers philosophical speculation on one's life. Reality is a soap opera and no less silly. A society is portrayed in which values are interchanged. Brushing one's teeth is as important as someone's death. One episode has no more meaning than the next. Time seems to be amputated into nonexistence and is replaced by wooden and splintering motion that has no beginning or end.

Sig Mickelson, a former president of CBS News, wrote a book about television entitled *The Electric Mirror* (1972). In it he points out that television mirrors reality. Psychoanalysts call the phenomenon transference. Almost at the moment of perception a simultaneous afterimage effect occurs in our subconscious. The artificial image becomes more "real" than the actual one. Recently a San Francisco news team visited a black ghetto and overheard neighborhood children remarking with excited anticipation about the advent of becoming "real," or appearing on television. Werner Erhard, founder of EST, takes advantage of the fractured-reality principle by using larger-than-life video screens in his seminars. He orchestrates duets between himself and his televised image. The combination has been terrifically effective in audience seduction.

Walter Cronkite notes that we live in a time when almost all news stories are related. News of a Cambodian invasion results in a tragedy at Kent State. News stories have become a type of modern literature that occasionally becomes difficult to separate from fiction. News reporting is a theatre of changing circumstances that introduce our culture's heroes and villains. Patti Hearst and Cinque, for example, unravel like actors in a Shakespeare play, as their lives become a spectator's sport. Reenactments of immediately past events

feed the television mirage factory surreptitious and compactly fitted dramas.

Scientists report that the television attention span is eleven seconds. This is four seconds shorter than most commercials. Short yet intense, commercials have become electronic haiku. Antropological teasers that reveal our cultist anxieties.

The extracted film of television, video tape has introduced a new way of producing images. It is an extension of the print. Instead of being made by acids and tools, the etching is being processed photochemically and in time sequences. Video decomposes a three-dimensional extension, translates it to a one-dimensional electrical flow, and finally releases a flat two-dimensional image. All of this is done within a time-elapsing frame. Video art is a manifestation of contemporary art. While there has been a great deal of video activity, video artists still exist in relationship to television.

Television appeals to the quiet intimacy of one's home. Sitting relaxed in a comfortable chair and perhaps sipping a beer are part of the properties. David Ross, video and television curator for the Long Beach Museum of Art, is trying to obtain a museum-run television station on which artists can broadcast their work directly from the museum into the home. Already existing commercial television circuits seem to be the natural way for video artists to form their connections.

Michael Asher was recently given one half hour of commercial broadcasting time in Seattle, where he created a pattern of his prescription to be broadcast.

Terry Fox completed a series of short (under one minute) video films that will be aired this year [1976] on public television in conjunction with the Floating Museum. His minidramas are shrouded in mystery as they translate the basic education of elementary science principles. He economizes on materials, using those available and familiar to everyone. For example, drops of water deftly placed on a cross of broken matchsticks causes the wood to swell and redirect itself into a starburst pattern. Another film shows the trapping of a greedy fly that enters two honey-filled spoons. His visuals carry the tension and moral concern of Aesop's fables.

Eleanor Coppola combines ideas of reality discrepancies in a series of short films in which she creates recipes for new perceptions that become the content of the form.

Television has replaced the printed word with body English. A grammar of homogenized characters, tailored narratives, and promiscuously used reflected realities comprise the backbone of this fifth communications revolution. Preoccupied with image transformations that are transparently overlaid on our minds, television creates time environments that dissolve our preconceptions as they challenge our fundamental notions of reality. Television remains an exciting adventure, through which is monitored the impulses of our age.

LITERARY VIDEO

RICHARD KOSTELANETZ

Approaches to the video medium are numerous and seem to involve virtually every art form. In this essay Richard Kostelanetz discusses an idea concerning a particularly literary approach to video. He feels that the mechanics of video lend themselves to a literary concept, and he cites several examples to indicate a closeness to prose and literary narration.

Kostelanetz distinguishes between ordinary television—a mass medium —and video, which he terms a private idiom geared to "an audience that is ideally both visually sensitive and literate."

Richard Kostelanetz has edited several anthologies of literature, art criticism, and social thought. He has created visual poems and stories and authored books on criticism and cultural history.

Of course, in this electric age of computers, satellites, radio and television, the writer can no longer be someone who sits up in his garret pounding a typewriter.

—Marshall McLuhan, 1966

Literary video differs from other video art in its base of a text whose language is enhanced, rather than mundane—a text that is conceived within the traditions of literature and a contemporary sense of verbal possibilities.

Literary video differs from video literary-reportage, in which, typically, a poet is interviewed or is seen reading aloud; for in literary video, the author becomes an artist, exploiting the indigenous possibilities of the new medium—instant playback, overdubbing, image distortion in live time, and so forth. In literary video, the screen is intelligently active, the author-artist visually enhancing his own language; in video reportage, the camera's eye is visually dumb.

Literary video draws upon both literary materials, and video possibilities and integrates them, rather than keeping them separate, so that word complements image and vice versa.

The video medium itself is closer to books than film, because the television screen is small and perceptually distant, like the printed page, rather than large and enveloping, like the movie screen; and literary video is customarily "read" like a book, in small groups or alone. (Most of us feel no qualms about interrupting someone watching a television or reading a book, while people at the movies remain undisturbed.)

Because the video image is less precise than the film image, and the former's light source is behind the screen, video is conducive to antirealism, but that perceptual distance between the viewer and the screen inhibits the experience of dreaminess. Video offers an arsenal of techniques for producing instant distortion—a surrealism that, because of the screen's size, is more painterly (if not literary) than filmic.

Because the video screen is much smaller than the movie screen, video is not effective in reproducing proscenium theatre; even conventional films look ungainly within such a tiny frame. It is conducive to individuals rather than choruses, to faces (and parts of faces) rather than milieus, to one or two voices rather than several. The video image tends to be more flat (two-dimensional), more tightly structured, and less cluttered—less like a film than a book.

Literary video should transcend the familiar representationalism of conventional television and the conventional syntax of familiar literature; it should also transcend those constraints of subject, theme, and truth that constrict the storytelling of commercial television.

An artist making a video tape may, unlike the filmmaker, examine his finished product immediately upon completing it; the process resembles rewriting at the typewriter.

The video medium lends itself to the presentation of continuous movement and, thus, not to poetry but to prose and to narrative.

Television is a mass medium; video a private one. Television is treasured for its credibility; video for its incredibility. Literary video is destined for an audience that is ideally both visually sensitive and literate; television for an audience that is neither.

My own video work is simple in certain respects and complex in

others. So is most writing. However, I make simple what others render complexly, and make complex certain dimensions that others render simply.

As a full-time writer, I bring language, with which I am familiar, to video, which I have scarcely explored. Although I won't abandon one art to do another—a 1960s fashion—I am, as a creative writer, currently experimenting not just vertically, within literary art; but horizontally, with media other than the small rectangular page—silk-screened prints, offset posters, ladderbooks, collections of cards, audio tape, and now video tape.

For "Plateaux," which relates the stages of a love affair in one-word paragraphs, I introduced an evolving moiré pattern; for "Excelsior," which switches rapidly between two voices, I created two abstract kinetic fields and then swiftly alternated between them. The central work in *Three Prose Pieces* (1975) is "Recyclings," in which nonsyntactic prose texts are read by several nonsynchronous voices, all of which are mine. The color image consists only of pairs of lips (mine), moving synchronously with the audible speech. The first section has one voice and one pair of lips; the last (and sixth) section has six audible voices and six pairs of visible lips.

For another tape, *Openings & Closings* (1975), a collection of single-sentence stories, which are alternately the openings and closings of hypothetically longer fiction, I instructed the engineer to alternate between color and black-and-white camera crews, and then instructed each crew to make its current visual image of me reading as different as possible from the one before in order to realize visually the leaps of time and space that characterize the prose text.

Remarkably few "writers" have made creative video, although an army of poetic eminences have had their faces and voices memorialized on half-inch black-and-white tape. It is surprising that no literary funding agency has ever, to my knowledge, supported literary video, for reportage, that artistically lesser form, rips off all the available funds. Intelligent literary video is less lucrative than dumb.

Literary video will not supersede the printed page but will become yet another possibility for heightened language.

VIDEO: THE AESTHETICS OF NARCISSISM

ROSALIND KRAUSS

In this article Rosalind Krauss discusses two characteristics of most video artworks: the simultaneous reception and projection of video images and the fact that the human psyche always appears in the role of conduit.

Video is a unique medium in that it is capable of recording and transmitting at the same time, producing instant feedback. And the human body is the central vehicle, or instrument, for all such recording. "The body is therefore as it were centered between two machines that are the opening and closing of a parenthesis," writes Krauss. "The first of these is the camera; the second is the monitor, which reprojects the performer's image with the immediacy of a mirror."

The phenomenon is identifiable, in a variety of ways, in the work of numerous video artists. Several of those discussed in this essay include Richard Serra, Nancy Holt, Vito Acconci, Lynda Benglis, and Joan Jonas.

Rosalind Krauss is associate professor of art history at Hunter College and editor of October *magazine. She is the author of* Terminal Iron Works/The Sculpture of David Smith *(1971).*

It was a commonplace of criticism in the 1960s that a strict application of symmetry allowed a painter "to point to the center of the canvas" and, in so doing, to invoke the internal structure of the picture-object. Thus "pointing to the center" was made to serve as one of the many blocks in that intricately constructed arch by which the criticism of the last decade sought to connect art to ethics through the "aesthetics of acknowledgment." But what does it mean to point to the center of a TV screen?

In a way that is surely conditioned by the attitudes of pop art,

43

artists' video is largely involved in parodying the critical terms of abstraction. Thus when Vito Acconci makes a video tape called *Centers* (1971), what he does is literalize the critical notion of "pointing" by filming himself pointing to the center of a television monitor, a gesture he sustains for the twenty-minute running time of the work. The parodistic quality of Acconci's gesture, with its obvious debt to Duchampian irony, is clearly intended to disrupt and dispense with an entire critical tradition. It is meant to render nonsensical a critical engagement with the formal properties of a work, or indeed, a genre of works—such as "video." The kind of criticism *Centers* attacks is obviously one that takes seriously the formal qualities of a work, or tries to assay the particular logic of a given medium. And yet, by its very mise-en-scène, *Centers* typifies the structural characteristics of the video medium. For *Centers* was made by Acconci's using the video monitor as a mirror. As we look at the artist sighting along his outstretched arm and forefinger toward the center of the screen we are watching, what we see is a sustained tautology: a line of sight that begins at Acconci's plane of vision and ends at the eyes of his projected double. In that image of self-regard is configured a narcissism so endemic to works of video that I find myself wanting to generalize it as *the* condition of the entire genre. Yet, what would it mean to say, "The medium of video is narcissism?"

For one thing, that remark tends to open up a rift between the nature of video and that of the other visual arts. Because that statement describes a psychological rather than a physical condition, and while we are accustomed to thinking of psychological states as the possible subject of works of art, we do not think of psychology as constituting their medium. Rather, the medium of painting, sculpture, or film has much more to do with the objective, material factors specific to a particular form: pigment-bearing surfaces; matter extended through space; light projected through a moving strip of celluloid. That is, the notion of a medium contains the concept of an object-state, separate from the artist's own being, through which his intentions must pass.

Video depends—in order for anything to be experienced at all—on a set of physical mechanisms. So perhaps it would be easiest to say that this apparatus—both at its present and at its future levels of technology—comprises the television medium, and leave it at that.

Yet with the subject of video, the ease of defining it in terms of its machinery does not seem to coincide with accuracy; and my own experience of video keeps urging me toward the psychological model.

Everyday speech contains an example of the word *medium* used in a psychological sense; the uncommon terrain for that common-enough usage is the world of parapsychology: telepathy, extrasensory perception, and communication with an afterlife, for which people with certain kinds of psychic powers are understood to be mediums. Whether or not we give credence to the fact of mediumistic experience, we understand the referents for the language that describes it. We know, for instance, that configured within the parapsychological sense of the word *medium* is the image of a human receiver (and sender) of communications arising from an invisible source. Further, this term contains the notion that the human conduit exists in a particular relation to the message, which is one of temporal concurrence. Thus, when Freud lectures on the phenomenon of telepathic dreams, he tells his audience that the fact insisted upon by reports of such matters is that the dreams occur at the *same time* as the actual (but invariably distant) event.

Now, these are the two features of the everyday use of *medium* that are suggestive for a discussion of video: the simultaneous reception and projection of an image; and the human psyche used as a conduit. Because most of the work produced over the very short span of video art's existence has used the human body as its central instrument. In the case of work on tape this has most often been the body of the artist-practitioner. In the case of video installations it has usually been the body of the responding viewer. And no matter whose body has been selected for the occasion, there is a further condition that is always present. Unlike the other visual arts, video is capable of recording and transmitting at the same time—producing instant feedback. The body is therefore as it were centered between two machines that are the opening and closing of a parenthesis. The first of these is the camera; the second is the monitor, which reprojects the performer's image with the immediacy of a mirror.

The effects of this centering are multiple. And nowhere are they more clearly named than in a tape made by Richard Serra, with the help of Nancy Holt, who made herself its willing and eloquent subject. The tape is called *Boomerang* (1974), and its situation is a re-

Nancy Holt and Robert Smithson: *East Coast, West Coast*. 1969. Black & white, with sound, 20 mins. Courtesy Castelli-Sonnabend Tapes and Films, New York. Photograph: Gwenn Thomas.

Richard Serra: *Boomerang.* 1974. Color, with sound, 10 mins. Courtesy
Castelli-Sonnabend Tapes and Films, New York.

cording studio in which Holt sits in a tightly framed close-up wearing
a technician's headset. As Holt begins to talk, her words are fed back
to her through the earphones she wears. Because the apparatus is
attached to a recording instrument, there is a slight delay (of less
than a second) between her actual locution and the audio feedback
to which she is forced to listen. For the ten minutes of the tape, Holt
describes her situation. She speaks of the way the feedback inter-
feres with her normal thought process and of the confusion caused
by the lack of synchronism between her speech and what she hears
of it. "Sometimes," she says, "I find I can't quite say a word because
I hear a first part come back and I forget the second part, or my
head is stimulated in a new direction by the first half of the word."

As we hear Holt speak and listen to that delayed voice echoing in
her ears, we are witness to an extraordinary image of distraction.
Because the audio delay keeps hypostatizing her words, she has
great difficulty coinciding with herself as a subject. It is a situation,
she says, that "puts a distance between the words and their appre-
hension—their comprehension," a situation that is "like a mirror re-
flection . . . so that I am surrounded by me and my mind surrounds
me . . . there is no escape."

The prison Holt both describes and enacts, from which there is
no escape, could be called the prison of a collapsed present, that is,
a present time that is completely severed from a sense of its own
past. We get some feeling for what it is like to be stuck in that
present when Holt at one point says, "I'm throwing things out in the
world and they are boomeranging back . . . boomeranging . . .
eranginging . . . anginging." Through that distracted reverberation
of a single word—and even word fragment—there forms an image of
what it is like to be totally cut off from history, even, in this case,
the immediate history of the sentence one has just spoken. Another
word for that history from which Holt feels herself to be discon-
nected is *text*.

Most conventional performers are of course enacting or interpret-
ing a text, whether that is a fixed choreography, a written script, a
musical score, or a sketchy set of notes around which to improvise.
By the very fact of that relationship, the performance ties itself to
the fact of something that existed before the given moment. Most
immediately, this sense of something having come before refers to

the specific text for the performance at hand. But in a larger way it evokes the more general historical relationship between a specific text and the history constructed by all the texts of a given genre. Independent of the gesture made within the present, this larger history is the source of meaning for that gesture. What Holt is describing in *Boomerang* is a situation in which the action of the mirror reflection (which is auditory in this case) severs her from a sense of text: from the prior words she has spoken; from the way language connects her both to her own past and to a world of objects. What she comes to is a space where, as she says, "I am surrounded by me."

Self-encapsulation—the body or psyche as its own surround—is everywhere to be found in the corpus of video art. Acconci's *Centers* is one instance, another is his *Air Time* (1973). In *Air Time* Acconci sits between the video camera and a large mirror, which he faces. For thirty-five minutes he addresses his own reflection with a monologue in which the terms *I* and *you*—although they are presumed to be referring to himself and an absent lover—are markers of the autonomous intercourse between Acconci and his own image. Both *Centers* and *Air Time* construct a situation of spatial closure, promoting a condition of self-reflection. The response of the performer is to a continually renewed image of himself. This image, supplanting the consciousness of anything prior to it, becomes the unchanging text of the performer. Skewered on his own reflection, he is committed to the text of perpetuating that image. So the temporal concomitant of this situation is, like the echo effect of *Boomerang,* the sense of a collapsed present.

Bruce Nauman's tapes are another example of the double effect of the performance for the monitor. In *Revolving Upside Down* (1968) Nauman films himself through a camera that has been rotated so that the floor on which he stands is at the top of the screen. For sixty very long minutes, Nauman slowly moves, turning on one foot, from the depths of his studio forward toward the monitor and then back again, repeating this activity until the tape runs out.

In Lynda Benglis's *Now* (1973), there is a similar leveling out of the effects of temporality. The tape is of Benglis's head in profile, performing against the backdrop of a large monitor on which an earlier tape of herself doing the same actions, but reversed left and right, is being replayed. The two profiles, one "live," the other taped,

Vito Acconci: *Recording Studio from Air Time.* 1973. Black & white, with sound, 35 mins. Courtesy Castelli-Sonnabend Tapes and Films, New York.

Lynda Benglis: *Now*. 1973. Color, with sound, 12 mins., 30 secs. Courtesy
Castelli-Sonnabend Tapes and Films, New York.

move in mirrored synchrony with one another. As they do, Benglis's two profiles perform an autoerotic coupling, which, because it is being recorded, becomes the background for another generation of the same activity. Through this spiral of infinite regress, as the face merges with the double and triple reprojections of itself merging with itself, Benglis's voice is heard either issuing the command "Now!" or asking, "Is it now?" Clearly, Benglis is using the word *now* to underline the ambiguity of temporal reference: We realize that we do not know whether the sound of the voice is coming from the live or the taped source, and if from the latter, which level of taping. Just as we also realize that because of the activity of replaying the past generations, all layers of the "now" are equally present.

But what is far more arresting in *Now* than the technological banality of the question "Which 'now' is intended?" is the way the tape enacts a collapsed present time. In that insistence it connects itself to the tapes by Nauman and Acconci already described, and ultimately to *Boomerang*. In all these examples the nature of video performance is specified as an activity of bracketing out the text and substituting for it the mirror reflection. The result of this substitution is the presentation of a self understood to have no past, and as well, no connection with any objects that are external to it. For the double that appears on the monitor cannot be called a true external object. Rather it is a displacement of the self that has the effect—as Holt's voice has in *Boomerang*—of transforming the performer's subjectivity into another, mirror, object.

It is at this point that one might want to go back to the proposition with which this argument began and raise a particular objection. Even if it is agreed, one might ask, that the medium of video art is the psychological condition of the self split and doubled by the mirror reflection of synchronous feedback, how does that entail a "rift" between video and the other arts? Isn't it rather a case of video's using a new technique to achieve continuity with the modernist intentions of the rest of the visual media? Specifically, isn't the mirror reflection a variant on the reflexive mode in which contemporary painting, sculpture, and film have successively entrenched themselves? Implicit in this question is the idea that autoreflection and reflexiveness refer to the same thing—that both are cases of consciousness doubling back upon itself in order to perform and portray a separation between forms of art and their contents, be-

tween the procedures of thought and their objects.[1] In its simplest form this question would be the following: Aside from their divergent technologies, what is the difference, *really*, between Vito Acconci's *Centers* and Jasper Johns's *American Flag?*

Answer: The difference is total. Reflection, when it is a case of mirroring, is a move toward an external symmetry; whereas reflexiveness is a strategy to achieve a radical asymmetry, from within. In his *American Flag*, Johns uses the synonomy between an image (the flag) and its ground (the limits of the picture surface) to unbalance the relationship between the terms *picture* and *painting*. By forcing us to see the actual wall on which the canvas hangs as the background for the pictorial object-as-a-whole, Johns drives a wedge between two types of figure/ground relationships: the one that is internal to the image and the one that works from without to define this object as Painting. The figure/ground of a flat, bounded surface hung against a wall is isolated as a primary, categorical condition, within which the terms of the process of painting are given. The category Painting is established as an object (or a text) whose subject becomes this particular painting—*American Flag*. The flag is thus both the object of the picture, *and* the subject of a more general object (Painting) to which *American Flag* can reflexively point. Reflexiveness is precisely this fracture into two categorically different entities that can elucidate one another insofar as their separateness is maintained.

Mirror reflection, on the other hand, implies the vanquishing of separateness. Its inherent movement is toward fusion. The self and its reflected image are of course literally separate. But the agency of reflection is a mode of appropriation, of illusionistically erasing the difference between subject and object. Facing mirrors on opposite walls squeeze out the real space between them. When we look at *Centers*, we see Acconci sighting along his arm to the center of the screen we are watching. But latent in this setup is the monitor that he is, himself, looking at. There is no way for us to see *Centers* without reading that sustained connection between the artist and his

[1] For example, this completely erroneous equation allows Max Kozloff to write that narcissism is "the emotional correlate of the intellectual basis behind self-reflexive modern art." See "Pygmalion Reversed," *Artforum*, 14 (November 1975): 37.

double. So for us as for Acconci, video is a process that allows these two terms to fuse.

One could say that if the reflexiveness of modernist art is a *dé-doublement*, or doubling back, in order to locate the object (and thus the objective conditions of one's experience), the mirror reflection of absolute feedback is a process of bracketing out the object. This is why it seems inappropriate to speak of a physical medium in relation to video. For the object (the electronic equipment and its capabilities) has become merely an appurtenance. And instead, video's real medium is a psychological situation, the very terms of which are to withdraw attention from an external object—an Other —and invest it in the Self. Therefore, it is not just any psychological condition one is speaking of. Rather it is the condition of someone who has, in Freud's words, "abandoned the investment of objects with libido and transformed object-libido into ego-libido." And that is the specific condition of narcissism.

By making this connection, then, one can recast the opposition between the reflective and reflexive, into the terms of the psychoanalytic project. Because it is there, too, in the drama of the couched subject, that the narcissistic reprojection of a frozen self is pitted against the analytic (or reflexive) mode.[2] One finds a particularly useful description of that struggle in the writing of Jacques Lacan.

In *The Language of the Self* Lacan begins by characterizing the space of the therapeutic transaction as an extraordinary void created by the silence of the analyst. Into this void the patient projects the monologue of his own recitation, which Lacan calls "the monumental construct of his narcissism." Using this monologue to explain himself and his situation to his silent listener, the patient begins to experience a very deep frustration. And this frustration, Lacan

[2] Freud's pessimism about the prospects of treating the narcissistic character is based on his experience of the narcissist's inherent inability to enter into the analytic situation: "Experience shows that persons suffering from the narcissistic neuroses have no capacity for transference, or only insufficient remnants of it. They turn from the physician, not in hostility, but in indifference. Therefore they are not to be influenced by him; what he says leaves them cold, makes no impression on them, and therefore the process of cure which can be carried through with others, the revivification of the pathogenic conflict and the overcoming of the resistance due to the repressions, cannot be effected with them. They remain as they are." Sigmund Freud, *A General Introduction to Psychoanalysis,* trans. Joan Rivere (New York: Permabooks, 1953), p. 455.

charges, although it is initially thought to be provoked by the maddening silence of the analyst, is eventually discovered to have another source:

> Is it not rather a matter of a frustration inherent in the very discourse of the subject? Does the subject not become engaged in an ever-growing dispossession of that being of his, concerning which—by dint of sincere portraits which leave its idea no less incoherent, of rectifications which do not succeed in freeing its essence, of stays and defenses which do not prevent his statue from tottering, of narcissistic embraces which become like a puff of air in animating it—he ends up by recognizing that this being has never been anything more than his construct in the Imaginary and that this construct disappoints all his certitudes? For in this labor which he undertakes to reconstruct this construct *for another,* he finds again the fundamental alienation which made him construct it *like another one,* and which has always destined it to be stripped from him *by another.*[3]

What the patient comes to see is that this "self" of his is a projected object and that his frustration is due to his own capture by this object with which he can never really coincide. Further, this "state" that he has made and in which he believes is the basis for his "static state," for the constantly "renewed status of his alienation." Narcissism is characterized, then, as the unchanging condition of a perpetual frustration.[4]

The process of analysis is one of breaking the hold of this fascination with the mirror; and in order to do so, the patient comes to see the distinction between his lived subjectivity and the fantasy projections of himself as object. "In order for us to come back to a more dialectical view of the analytic experience," Lacan writes, "I would say that the analysis consists precisely in distinguishing the person lying on the analyst's couch from the person who is speaking. With

[3] Jacques Lacan, *The Language of the Self,* trans. Anthony Wilden (New York: Delta, 1968), p. 11.

[4] Explaining this frustration, Lacan points to the fact that even when "the subject makes himself an object by striking a pose before the mirror, he could not possibly be satisfied with it, since even if he achieved his most perfect likeness in that image, it would still be the pleasure of the other that he would cause to be recognized in it." *Ibid.,* p. 12.

56 ROSALIND KRAUSS

the person listening [the analyst], that makes three persons present in the analytical situation, among whom it is the rule that the question . . . be put: Where is the *moi* of the subject?"⁵ The analytic project is then one in which the patient disengages from the "statue" of his reflected self, and through a method of reflexiveness, redis-covers the real time of his own history. He exchanges the atemporal-ity of repetition for the temporality of change.

If psychoanalysis understands that the patient is engaged in a re-covery of his being in terms of its real history, modernism has un-derstood that the artist locates his own expressiveness through a discovery of the objective conditions of his medium and their his-tory. That is, the very possibilities of finding his subjectivity necessi-tate that the artist recognize the material and historical independence of an external object (or medium).

In contradistinction to this, the feedback coil of video seems to be the instrument of a double repression: For through it consciousness of temporality and of separation between subject and object are simultaneously submerged. The result of this submergence is, for the maker and the viewer of most video art, a kind of weightless fall through the suspended space of narcissism.

There are, of course, a complex set of answers to the question of why video has attracted a growing set of practitioners and collectors. These answers would involve an analysis of everything from the problem of narcissism within the wider context of our culture to the specific inner workings of the present art market. Although I should like to postpone that analysis for a future essay, I do wish to make one connection here. And that is between the institution of a self formed by video feedback and the real situation that exists in the art world from which the makers of video come. In the last fifteen years that world has been deeply and disastrously affected by its relation to mass media. That an artist's work be published, reproduced, and disseminated through the media has become, for the generation that has matured in the course of the last decade, virtually the *only* means of verifying its existence as art. The demand for instant re-play in the media—in fact the creation of work that literally does not exist outside of that replay, as is true of conceptual art and its nether

⁵ *Ibid.*, p. 100. Although *moi* translates as "ego," Wilden has presumably retained the French here in order to suggest the relationship between the differ-ent orders of the self by the implicit contrast between *moi* and *je*.

side, body art—finds its obvious correlative in an aesthetic mode by which the self is created through the electronic device of feedback.

There exist, however, three phenomena within the corpus of video art that run counter to what I have been saying so far, or at least are somewhat tangential to it. They are: (1) tapes that exploit the medium in order to criticize it from within; (2) tapes that represent a physical assault on the video mechanism in order to break out of its psychological hold; and (3) installation forms of video, which use the medium as a subspecies of painting or sculpture. The first is represented by Richard Serra's *Boomerang*. The second can be exemplified by Joan Jonas's *Vertical Roll* (1972). And the third is limited to certain of the installation works of Bruce Nauman and Peter Campus, particularly Campus's two companion pieces *mem* (1974) and *dor*.

I have already described how narcissism is enacted in *Boomerang*. But what separates it from, say, Benglis's *Now*, is the critical distance it maintains on its own subject. This is primarily due to the fact that Serra employs audio rather than visual feedback. Because of this, the angle of vision we take on the subject does not coincide with the closed circuit of Holt's situation, but looks onto it from outside. Further, the narcissistic condition is given through the cerebrated form of language, which opens simultaneously onto the plane of expression and the plane of critical reflexiveness.

Significantly, Serra's separation from the subject of *Boomerang*, his position outside it, promotes an attitude toward time that is different from many other works of video. The tape's brevity—it is ten minutes long—is itself related to discourse: to how long it takes to shape and develop an argument and how long it takes for its receiver to get the "point." Latent within the opening situation of *Boomerang* is its own conclusion; when that is reached, it stops.

Vertical Roll is another case where time has been forced to enter the video situation, and where that time is understood as a propulsion toward an end. In this work access to a sense of time has come from fouling the stability of the projected image by desynchronizing the frequencies of the signals on camera and monitor. The rhythmic roll of the image, as the bottom of its frame scans upward to hit the top of the screen, causes a sense of decomposition that seems to work against the grain of those 525 lines of which the video picture is made. Because one recognizes it as intended, the vertical roll ap-

Joan Jonas: *Vertical Roll*. 1972. Black & white, with sound, 20 mins.
Courtesy Castelli-Sonnabend Tapes and Films, New York.

pears as the agency of a will that runs counter to an electronically stabilized condition. Through the effect of its constant wiping away of the image, one has a sense of a reflexive relation to the video grid and the ground or support for what happens to the image.

Out of this is born the subject of *Vertical Roll*, which visualizes time as the course of a continuous dissolve through space. In it a sequence of images and actions are seen from different positions—both in terms of the camera's distance and its orientation to a horizontal ground. With the ordinary grammar of both film and video these shifts would have to be registered either by camera movement (in which the zoom is included as one possibility) or by cutting. And while it is true that Jonas has had to use these techniques in making *Vertical Roll*, the constant sweep of the image renders these movements invisible. That is, the grammar of the camera is eroded by the dislocating grip of the roll. As I have said, the illusion this creates is one of a continuous dissolve through time and space. The monitor, as an instrument, seems to be winding into itself a ribbon of experience, like a fishing line being taken up upon a reel, or like magnetic tape being wound upon a spool. The motion of continuous dissolve becomes, then, a metaphor for the physical reality not only of the scan lines of the video raster, but of the physical reality of the tape deck, whose reels objectify a finite amount of time.

Earlier, I described the paradigm situation of video as a body centered between the parenthesis of camera and monitor. Due to *Vertical Roll*'s visual reference through the monitor's action to the physical reality of the tape, one side of this parenthesis is made more active than the other. The monitor side of the double bracket becomes a reel through which one feels prefigured the imminence of a goal or terminus for the motion. That end is reached when Jonas, who has been performing the actions recorded on the tape, from within the coils of the camera/monitor circuit, breaks through the parenthetical closure of the feedback situation to face the camera directly—without the agency of the monitor's rolling image.

If it is the paired movement of the video scan and the tape reel that is isolated as a physical object in *Vertical Roll*, it is the stasis of the wall plane that is objectified in Campus's *mem* and *dor*. In both of the Campus works there is a triangular relationship created between: (1) a video camera, (2) an instrument that will project the

Joan Jonas: *Vertical Roll*. 1972. Black & white, with sound, 20 mins.
Courtesy Castelli-Sonnabend Tapes and Films, New York.

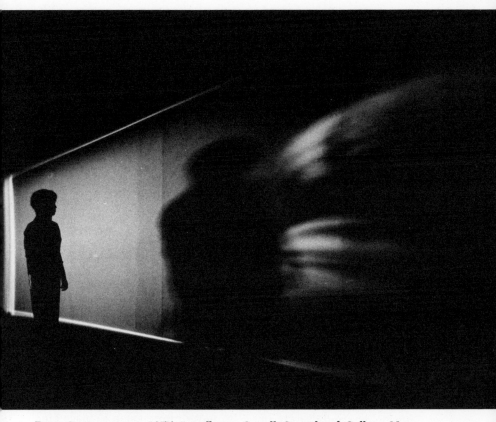

Peter Campus: *mem*. 1975. Installation Castelli-Sonnabend Gallery, New
York. Courtesy Castelli-Sonnabend Tapes and Films, New York. Photo-
graph: Bevan Davies.

live camera image onto the surface of a wall (at life- and over-life-size), and (3) the wall itself. The viewer's experience of the works is the sum of the cumulative positions his body assumes within the vectors formed by these three elements. When he stands outside the triangular field of the works, the viewer sees nothing but the large, luminous plane of one of the walls in a darkened room. Only when he moves into the range of the camera is he able to realize an image (his own) projected onto the wall's pictorial field. However, the conditions of seeing that image are rather special in both *mem* and *dor*.

In the latter the camera is placed in the hallway leading to the room that contains the projector. Inside the room, the viewer is out of the range of the camera and therefore nothing appears on the wall surface. It is only as he leaves the room, or rather is poised at the threshold of the doorway that he is both illumined enough and far enough into the focal range of the camera to register as an image. Since that image projects onto the very wall through which the doorway leads, the viewer's relation to his own image must be totally peripheral; he is himself in a plane that is not only parallel to the plane of the illusion but continuous with it. His body is therefore both the substance of the image and, as well, the slightly displaced substance of the plane onto which the image is projected.

In *mem* both camera and projector are to one side of the wall plane, stationed in such a way that the range of the camera encompasses a very thin corridorlike slice of space that is parallel to, and almost fused with, the illumined wall. Due to this, the viewer must be practically up against the wall in order to register. As he moves far enough away from the wall in order to be able to see himself, the image blurs and distorts, but if he moves near enough to place himself in focus, he has formed such closure with the support for the image that he cannot really see it. Therefore in *mem*, as in *dor*, the body of the viewer becomes physically identified with the wall plane as the "place" of the image.

There is a sense in which we could say that these two works by Campus simply take the live feedback of camera and monitor, which existed for the video artist while taping in his studio, and re-create it for the ordinary visitor to a gallery. However, *mem* and *dor* are not that simple. Because built into their situation are two kinds of invisibility: the viewer's presence to the wall in which he is himself

an absence and his relative absence from a view of the wall that becomes the condition for his projected presence upon its surface.

Campus's pieces acknowledge the very powerful narcissism that propels the viewer of these works forward and backward in front of the muralized field. And through the movement of his own body, his neck craning and head turning, the viewer is forced to recognize this motive as well. But the condition of these works is to acknowledge as separate the two surfaces on which the image is held—the one the viewer's body, the other the wall—and to make them register as absolutely distinct. It is in this distinction that the wall surface—the pictorial surface—is understood as an absolute Other, as part of the world of objects external to the self. Further, it is to specify that the mode of projecting oneself onto that surface entails recognizing all the ways that one does not coincide with it.

There is, of course, a history of the art of the last fifteen years into which works like *mem* and *dor* insert themselves, although it is one about which little has been written. That history involves the activities of certain artists who have made work that conflates psychologistic and formal means to achieve very particular ends. The art of Robert Rauschenberg is a case in point. His work, in bringing together groupings of real objects and found images and suspending them within the static matrix of a pictorial field, attempts to convert that field into something we could call the plane of memory. In so doing, the static pictorial field is both psychologized and temporally distended. I have argued elsewhere[6] that the impulse behind this move arose from questions that have to do with commodity fetishism. Rauschenberg, among many other artists, has been working against a situation in which painting and sculpture have been absorbed within a luxury market—absorbed so totally that their content has been deeply conditioned by their status as fetish prizes to be collected, and thereby consumed. In response, Rauschenberg's art asserts another, alternative relationship between the work of art and its viewer. And to do this, Rauschenberg has had recourse to the value of time: to the time it takes to read a text or a painting, to rehearse the activity of cognitive differentiation that that entails, to get its point. That is, he wishes to pit the temporal values of consciousness against the stasis of the commodity fetish.

[6] "Rauschenberg and the Materialized Image," *Artforum,* 13 (December 1974).

Although responsive to the same considerations, the temporal values that were built into the minimalist sculpture of the 1960s were primarily engaged with questions of perception. The viewer was therefore involved in a temporal decoding of issues of scale, placement, or shape—issues that are inherently more abstract than, say, the contents of memory. Pure, as opposed to applied psychology, we might say. But in the work of certain younger sculptors, Joel Shapiro for example, the issues of minimalism are being inserted into a space that, like Rauschenberg's pictorial field, defines itself as mnemonic. So that physical distance from a sculptural object is understood as being indistinguishable from temporal remove.

It is to this body of work that I would want to add Campus's art. The narcissistic enclosure inherent in the video medium becomes for him part of a psychologistic strategy by which he is able to examine the general conditions of pictorialism in relation to its viewers. It can, that is, critically account for narcissism as a form of bracketing out the world and its conditions at the same time as it can reassert the facticity of the object against the grain of the narcissistic drive toward projection.

VIDEO ART IN THE TV LANDSCAPE: NOTES ON SOUTHERN CALIFORNIA

KIM LEVIN

While most of the essays in this volume refer to New York video art, in this essay Kim Levin, a New York critic, confines her observations to the video art of southern California. Such art involves a somewhat different viewpoint and, in some respects, is a purer form of video art than that which is identified with New York.

The video artists emerging in California relate their art more to television than to art of the past. Television has offered a model for a new kind of narrative structure that is, according to Levin, both episodic and interrupted. At the same time it involves nonsequential and inconsequential interruptions. Such an interrupted narrative structure accurately reflects real life and is also closely linked to the new, highway-oriented southern California landscape. One result is a type of video art that is based upon the style and format of commercial television.

Among the artists discussed in this essay are Billy Adler, Lowell Darling, Chris Burden, Ilene Segelove, Susan Mogul, Bill Leavitt, Martha Rosler, Brian Connell, Fred Lonidier, Phil Steinmetz, Allan Sekula, Al Ruppersberg, Alexis Smith, and Eleanor Antin.

In the final analysis Kim Levin feels that video, in spite of its popularity, may not yet represent the answer to art's dilemma. "Television," she says, "may not be the ideal model."

Kim Levin has written extensively about art, and her articles have appeared in numerous art journals. The following essay was written while she was studying video art in California with the support of an NEA grant.

It is no accident that young artists in southern California are embracing video. While many of the artists who came to maturity there in the 1960s have been dealing with the immaterial image—with pure light and empty space—a new generation has turned to the immaterial medium.

Video, the gorilla godchild of Andy Warhol's Empire State Building,[1] sabotages all attempts at artifice. It stolidly insists on retaining actual time. When Ingmar Bergman showed a minute as an actual minute in a film years ago, it was stunning. When Warhol abolished time in his unmoving movies, it was stupefying. When video records an artist's private activities over a span of twenty minutes, it is endless. If Warhol made boredom permissible, conceptualism institutionalized it. Video adheres to an aesthetic of boredom. Appearing in the late 1960s at the same time as the art object was being demolished in other ways, it seemed the perfect medium for ideas, for art without baggage, for explorations of real time and duration. And, for a first generation of video artists, it was definitely nonnarrative.

At least so it seemed in the East. In California, where people style themselves after television characters and you can recognize the Rockfords and Barnaby Joneses at any local discount store, where people furnish their homes in Mae West modern or quiz-show decor, television is a central fact of life. In California, where Allan Kaprow has taught and the ideas of Fluxus circulated, television is the model, as both John Baldessari and William Wegman realized. It is only natural that a number of second-generation video artists are emerging whose use of the medium relates more directly to television than to past art. "We're all children of the media," they say. In the East, television retains a certain distance, due simply to the fact that it is "Made in California." Those palm trees, stucco houses, and sunny boulevards, where the latest car chase is happening, just aren't our terrain. In California, television is not only true to life, life is true to television. It was inevitable that duration would turn to narrative.

Television offers a new kind of narrative structure, episodic and interrupted, that incorporates within itself nonsequential, inconsequential interruptions. Breaks for station identification and commercials are recurring refrains, and within commercials these refrains are often in the form of mininarratives telling us intimate details of

[1] *Empire,* a film by Andy Warhol, 1962.

a family's personal hygiene. In the same way the episodes of any weekly series are separated by the rest of the weekly programming, so that the viewer carries chapters of unrelated stories simultaneously in his memory.

Life reinforces this interrupted narrative structure. Driving through the California landscape, there is an endless repetition of the same man-made scenery. Taco Belles, Sambos, Jack-in-the-Boxes recur with predictable regularity, like commercials on the TV screen. Indistinguishable suburban streets repeat with the familiarity of altered stage sets reused on different programs. Everything you do is punctuated by periods of being encapsulated in a car on a freeway, taking the place in life of the station break. Everyone thinks a lot about what they have just done, or fantasizes about what they might have done. A lot of mental rearranging takes place. As narrative content enters art, it is taking the form that life and television have offered; as narrative time becomes a field for investigation, video is obviously an appropriate medium. Television is the real subject of video.

Billy Adler, with supreme awareness of the relation between video and television, has collaged (in collaboration with John Margolies) a bunch of actual Nixon newsclips so that Nixon appears to be the host of a family variety show—playing the piano, doing a comic bit with a Yo-Yo, tossing insults and quips like a true trouper. Watergate is turned into a quiz show, while "The Inauguration" and "Impeachment" become spectaculars in his video collage. Adler knew that you can't beat the real thing; actual television is the original. He knew that nostalgia in L.A. is nostalgia for old TV—"Queen for a Day," "The Lone Ranger," Milton Berle, Captain Video—and he gathered choice bits from antique TV shows like a collection of old postcards. Lowell Darling knew it too. When he acupunctured L.A., he got coverage on the evening news, and he was divorced on network TV wearing a bridal gown. Chris Burden purchased commercial advertising time on L.A.'s Channel 9 and aired his *TV Ad* artwork nightly for a month.

Meanwhile other artists in Los Angeles are doing narrative video, structuring their work from television, intentionally or unintentionally. Ilene Segelove's *The New Room*, a sociological documentary in which a young housewife smugly shows off her new home im-

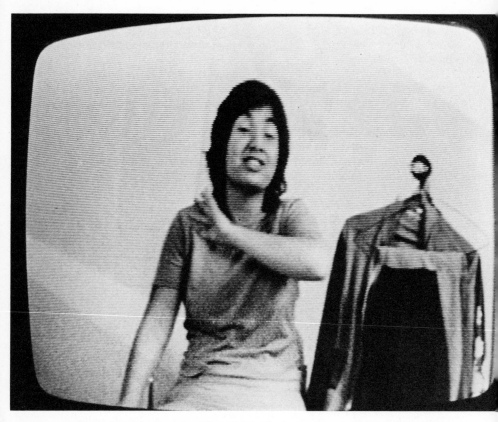

Susan Mogul: *Dressing Up*. 1975. Black & white, with sound, 10 mins.
Photograph courtesy the artist.

provements, is like watching the girl on the game show who displays the fabulous prizes behind the curtain. Susan Mogul's tapes *Take Off* and *Dressing Up*, both overflowing with vulgarity, are like commercials gone berserk. In the first, parodying Acconci, she alternates inane sales talk with demonstrations of a vibrator and a repeated chanted refrain; in the second, she chats about sales, discounts, and famous-make brands while munching peanuts and clumsily getting dressed in her bargains. Bill Leavitt's tapes have the brevity of commercials and the visual fascination with surfaces and materials, making a fetish of genteel elegance like ads about spotless glasses or dishes you can see your face in, while on the sound track disembodied soap-opera voices, out of touch with their feelings, talk blankly.

While video pieces in L.A. are being structured on commercials and commercial programs, ridiculing the follies of a materialistic culture, a group of politically oriented artists in San Diego take the news and the documentary as their models. In San Diego, narrative is a populist stance, and art becomes investigative reportage, exposing the evils of the society.

"We all do a lot of research," says Martha Rosler, whose short tape *Semiotics of the Kitchen* (1975) turns a Julia Child–type demonstration of cooking utensils into a hostile display of weaponry. "Gourmetism as an imperialist endeavor" is her stated concern; she uses cooking as a metaphor for art. "If you're looking for drama, you're not going to find it here," says the narrator of Brian Connell's *La Lucha Final* (1975), a long factual video piece about the attempted assassination of a U.S. ambassador in Latin America, using familiar news structures and eyewitness reports to piece together a story of sabotage.

Fred Lonidier uses photos, captions, texts, and video documentation to make vicious sociological commentaries that necessitate a kind of simultaneous episodic reading learned from television documentaries. Art is not immune from his commentary. "We're politicos," he says. "The thing is that most artists are anarchists at heart, sort of carpetbaggers and fly-by-nights, particularly the whole conceptualist thing." In an occupational-accident artwork documenting the disabilities of victims of industrial mishaps he is also calling attention to the fascist possibilities of conceptualist performances. "Conceptual artists have mutilated themselves. It's only one step

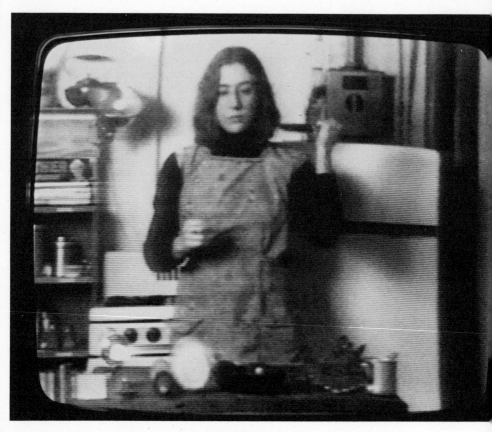

Martha Rosler: "Knife" from *Semiotics of the Kitchen*. 1975. Black & white, with sound, 7 mins. Photograph courtesy the artist.

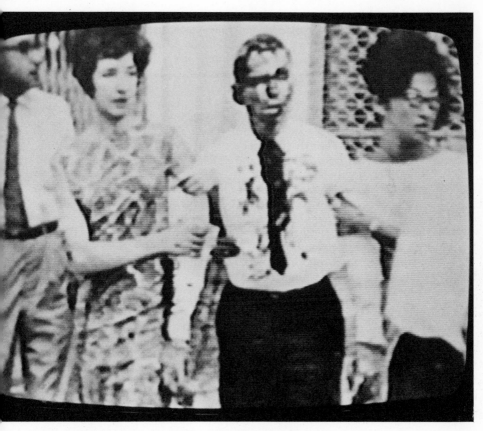

Brian Connell: *La Lucha Final*. 1975. Black & white, with sound, 30 mins.
Photograph courtesy the artist.

further to mutilate someone who doesn't want to be," he says. "My
work is a critique. I'm just trying to up the ante a little."

Television itself is a subject for Phil Steinmetz's commentary in a
picture book known as *The Evening News* (1974) in which the
bright cube of a TV screen in a dark room is the repeated format
of the photographs. On the screen, images from the evening news
are anecdotally paired with images from the interrupting commer-
cials—war disasters are mitigated by odes to Lysol and Midol.

In Allan Sekula's photonovel *Aerospace Folktales* (1973), a visual
biography in terms of ideology, sequences of photoreproductions
make a confessional documentary about his father's unemployment.
Toward the end of the book are several pages of images of book-
shelves, a catalogue of the man's literary tastes.

There is a peculiar relationship between the book and television:
Television has made the written word obsolete. Many artists using
video are also using the format of the picture book in video. Allan
Sekula's photonovels and Phil Steinmetz's picture books are part of
the video culture: Their sequential photographic images are seen
as stills translated from TV. Pages are meant to be flipped rapidly.
And if, as in *Aerospace Folktales*, the photoreproductions are gray
and grainy, it is just one more reference to the lack of definition in
an on-the-spot news report. While artists' books in L.A., such as
World Run, which Billy Adler made with Van Schley, tend to have
the slick professionalism of commercial advertising, in San Diego
they are less showy, as befits their didactic stance. Supported by
the university structure, these artists are a radical academic seg-
ment of the California art world, producing a curious militant edu-
cational art—a strange offshoot of conceptualism.

In postconceptual California, the medium is a matter of the con-
tent: Skill is something you pick up when you need it. Artists have
already learned from video. Al Ruppersberg, Alexis Smith, and
Eleanor Antin have all used video to tell stories. Their nonvideo
work reflects the interrupted narrative structure of television and
at the same time subverts it, acting as nostalgic commentaries of the
once upon a time when people actually read novels. It is as if Ray
Bradbury's *Fahrenheit 451* had come true.

When Al Ruppersberg wrote a paperback novel that was mostly
blank pages, he was commenting on the fact that the written word

Phil Steinmetz: Page from *The Evening News*. 1974. Black & white. Photograph courtesy the artist.

the engineer and his old friend stood in the empty
lockheed parking lot while i photographed them

unable to fathom my motives, they were uneasy

Allan Sekula: Two frames from *Aerospace Folktales*. 1973; installation
1975.

is obsolete. When he made a handwritten copy of *The Portrait of Dorian Grey* on twenty man-size canvases, turning a book about a painting into a painting about a book, he questioned what visualization is. In *The Footnote*, his recent three-panel work, a grid of books on shelves, photographed in living color, mimics a library wall, while a written text in the form of a narrative footnote scrawls across all three panels, speaking of suicide.

Alexis Smith's abbreviated commentaries on *Robinson Crusoe* and *The Scarlet Letter*, with the pages spread side by side on the wall, condense the essentials for the nonreading video culture, using sparse visual metaphors for the literary content like trademarks. Too slow for the instant vision of the traditional art viewer, too quick for the true reader, they function as signposts of the changes in perception wrought by television. The instant identification of symbols learned from countless commercials, the quick cut, the interrupted story, and the station break, enable us to read a desert island in a single segment of a jigsaw puzzle and a whole story in an inky footprint.

Eleanor Antin's episodic novelistic autobiographical performances also depend on a sensibility attuned to television. Her four different "performance selves," and her sliding in and out of character between the real Eleanor and these semifictional selves, are like switching channels or watching segments of different programs as one "self" preempts another. It is significant that, while they don't have the nostalgia of referring to actual stories written in the past, Antin's personages are all storyteller artists. Each has his own fictive oeuvre—the King's rococo meditations and watercolors, the Ballerina's impressionistic memoirs and sketches, the Nurse's romantic melodramas and paper dolls—not only relegating autobiography to fiction, but shifting the production of both literature and art to the realm of nostalgic historical fantasy.

Television may not be the ideal model. Video, in spite of its rapid proliferation, is not the answer to art's dilemma, not yet at least. But it is carrying clues to the new narrative. Baldessari, speaking of a growing disenchantment with video in 1974, said, "With enough disillusionment perhaps more artists will consider doing works using the real world. Consider real experience rather than hiding behind the screen. And this may be the real payoff and what we have all been heading toward. The real world may not be so bad."

ONE-GUN VIDEO ART

LES LEVINE

"Time moving through space," one of the descriptions of television that Les Levine sets forth here, serves to point out a major difference separating video from the plastic and three-dimensional art forms. "Video time" has created a level of consciousness resulting in new types of perception. In video, perception is "essentially a timing device."

Heat, screen size, zoom lens, and the special-effects generator are important appurtenances of video that have combined to signal the distinctive perception. Of these, exploitation of the special effects made possible by advanced video technology is perhaps the most significant development for the video medium.

In video special effects are created, via the technology, by a technical director, who, in many ways, is as important to the medium as the director is to a movie film. Significantly, the complex technology of video tends to militate against the video artist. Time base, time-base corrector, incidental light, EIA standards, and processing amplifiers combine with the nonphysical, electric nature of the medium to favor the highly skilled and well-financed commercial professionals and not the artist.

Les Levine concludes that video art is not truly television, rather it is the medium of television used to express conceptual ideas. In this article he explains in laymen's language the important technical facts that characterize the rapidly developing video technology.

Of these, Levine feels that the recent development of the one-gun color camera is perhaps the most significant, possessing the capability to "revolutionize the video industry."

Les Levine, who was born in Dublin, Ireland, currently lives in New York City. He has had over eighty one-man shows, the most reecnt at the M. L. D'Arc Gallery in New York, called "What the Federal Government Can Do for You." Levine regards himself as a "media sculptor" and, in addition to writing extensively, has produced environments, process pieces, systems pieces, documentation pieces, outdoor actions, video tapes, and films.

The television screen is measured diagonally. Most televisions are approximately eighteen inches across. Now you might well ask yourself, why would an artist be satisfied to deal with eighteen diagonal inches of space? The main issue that television deals with is time. No matter how large a sculpture or painting or drawing or anything else, we cannot identify the time base involved. We can't understand for what amount of time we're supposed to look at it. And because we can't understand the element of time, we can't deal with it perceptually, we can only deal with it intellectually.

What is happening in terms of the television, which seems to be one of the reasons it is so attractive to the artist, is the element of time and space. Time moving through space. Moving through a sense of time while the thing is happening. We see a painting holistically. All at once. As a complete experience. As something that is completely in front of us. We do not think for a moment that there is another part to it that is somewhere else. The cliché is that the painting on the wall operates in the same way that a window does. The painting takes you into another level of consciousness. The idea is that the wall itself represents the parameter of the space of your mind. The painting on the wall is a hole in that parameter, allowing your mind to get outside the space of the wall, allowing your mind to go into a kind of perceptual wavelength. However, it doesn't quite work that way because in general what happens is that the painting forces you back into the room. It is impossible to use the element of time in experiencing a painting or a sculpture.

The way that perception relates to time and space is very important in considering why the artist is involved in television. When a sign is sighted, the mind attempts to make some kind of idea out of that sign. If the mind is able to do it immediately, we have what is called perception.

Essentially, a target is sighted and perception represents a bull's-eye, hit in the center at first crack. If we can't hit the target, we will devise a model to find out how we can relate this to some kind of experience that we might understand. That is called intellectual behavior.

When dealing with quantities of time in terms of space and television, very minute quantities of time are expanded. Consider the timing of intellectual activity, the activity that has to occur when no perception is possible. Take one microsecond to represent per-

Les Levine at the control room console in the television studios at William Paterson College, Wayne, New Jersey. 1975. Courtesy Anna Canepa Video Distribution, Inc., New York. Photograph: Harry Shunk.

ception. And take three seconds to represent the length of time the mind needs to make the intellectual model necessary to describe to itself the experience that it is having. If we multiply either one of these by a factor of a thousand, we end up with something like perception coming out to be one second and intellection coming out to fifty minutes. In terms of actual real time, the difference is enormous.

Perception is essentially a timing device. The shorter the sighting time, the more perception is occurring. As the sighting time is expanded, the activity changes to intellectual. The quantity of time involved shapes the nature of brain behavior. In television the target is moving past you, the experience is being read for you. There is nobody between you and the experience. It is as though the experience is being pulled past your eye through space in time.

The rectangular tube is made up of phosphors. All information, all perception, everything that has to do with informing or sending knowledge from one person to another requires heat. You cannot generate information without heat. It can't be done.

The page of a book. White space with black type. The words on the page represent negative space causing interaction between it and the whiteness of the page, which causes friction in the eye and a sense of symbiotic heat in the body. Without that sense of symbiotic warmth, there is no possibility for reception of information. It can't occur. You cannot see color without heat. You cannot see form without heat. Simplistically, you require light to see. Light generates heat. In a highly perceptual experience, the body and the mind are attempting to create heat. That is the entire point of it. Heat. Everytime a perception occurs, heat is generated in the body.

Now come back to the television screen and its phosphors. The phosphors are heated up by electrons, bit particles of information that are formed into certain kinds of configurations so you can see the image on the screen. The image occurs on the screen as a series of very, very thin lines, which is no different essentially from the concept of halftone printing in books, where a series of little dots all over the page gives you the sensation that you are seeing a face. Without the dots, the halftone cannot be printed. In television, without the lines, the image cannot be perceived.

Television works on what we call a sixty-cycle blanking system. That means that for every complete set of bit particles, and there

Les Levine: *Magic Carpet*. 1975. Color, with sound, 30 mins. Courtesy Anna Canepa Video Distribution, Inc., New York. Photograph: Harry Shunk.

might be thousands in an image, we have one complete blank system. One system that completely covers the entire screen with blankness. There are sixty individual parts to each second of television. Thirty real information parts and thirty blank or empty parts, if you like, where nothing occurs on the screen. These parts are then put together in what we call the vertical interval system. And when you look at television, it appears to be actually happening before your eyes.

The fact that TV is produced in sixty cycles is of considerable importance, because sixty cycles turns out to be the way we count time. Time again is always coming up on television. Time. Sixty cycles, sixty seconds, sixty minutes, and so on. So there seems to be a direct relationship between the nature of the way television is produced and the nature of the way we naturally count time. That fact in itself creates a different kind of relationship to the medium of television than we have toward any other medium. In other words, we can say that TV is in our time base.

We also have another element of time. We never see a half hour of television. What we see is about seven or eight minutes of time at any given moment. That chops up the space in such a way as to move through time more easily.

The TV screen is a small screen. It is not a movie screen. You can go to the left or to the right with the camera. But you can't go very far. You can only go sixteen or eighteen inches. So pans don't work very well. You can move the other way, top to bottom, but tilts don't work very well either, because if you go up too much, you're in the lighting, and the lighting has a bad effect on the camera tubes.

So we're left with the idea of zooming. The zoom lens was invented for television. The zoom lens was developed out of necessity. Because given this little rectangle, there are very few spaces you can move to. So you're left with zooming and special effects.

SEG. Special-Effects Generator. Once you get into special effects, television is a formal medium. Most television productions are done with, let's say, four cameras. Camero one, camera two, camera three, and camera four. The standard situation is to open with a closeup shot, move back, identify the entire space, and then move in for a close-up again, a reaction shot, a wide angle, back to a close-up, a reaction shot, a midrange shot. You can see that permutations can turn out to be extremely geometric, where you get 4-3-2-1, 1-2-3-4,

3-2-1-4, and so on. You get this kind of geometric patterning going on till the end of the show, because the permutations are simply 1-2-3-4, and they are the only possibilities you have.

If film is a director's medium, then TV is a technical director's medium. The technical director can affect the final look of the program more than anyone else in the production. Camera work as we see it in film is almost nonexistent in television. The cameras could in fact be automated without making much difference to the final look of what is on the TV screen. Aesthetic camera work is almost impossible in television. What ends up on the television screen as the broadcast picture is a function of the medium's ability to switch back and forth between one piece of information and another in a fraction of a second. All of the things that represent manufacturing or hand labor in film, such things as editing, dissolving, superimposing, in television are done electronically in real time on a special-effects generator in a control room. In television there is no postproduction work to be done. The director must compose and make the finished product in the same time that the activity occurs.

A most simple, mundane activity, such as a talk or panel show, can be made to appear interesting or exciting by good technical directing, by dissolving from one panelist to the other, split-screening two panelists close up on either side of the screen, or by jumping the image quickly from one camera to the other to increase the rhythm of the image and improve the program's sense of timing. The director can orchestrate almost any event into a kind of image symphony, thereby holding the audience's interest so that the panel may deliver its information. In other words, a good director using a sophisticated special-effects generator can make time appear to be moving faster, thereby keeping the audience's interest.

Television studio cameras are extremely heavy. They weigh over one hundred pounds. They can't be hand held. So they have to be put on pedestals, and those pedestals are very difficult to move around. The camera operator operates it from the back of the camera. Everything that he needs to know is back there. He has a headset on. The headsets are connected directly to the control room. The control room may be as far as two hundred feet away. It may be as far as ten miles away. It doesn't really matter.

In the control room, the technical director pushes all the buttons on the SEG (special-effects generator). The director is looking at all

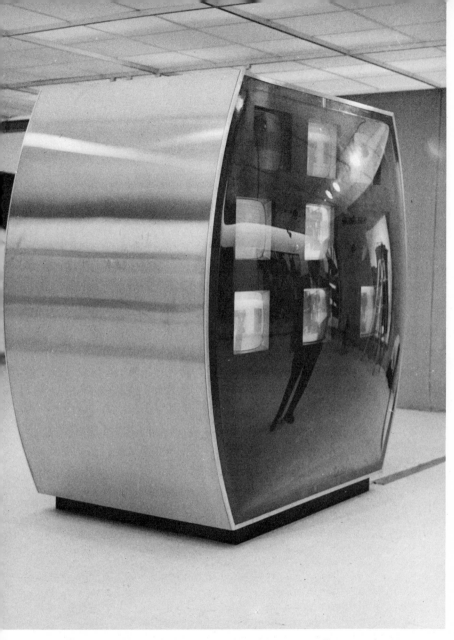

Les Levine: *Contact*, "a television sculpture." 1969. Collection The New York Cultural Center. Courtesy Anna Canepa Video Distribution, Inc., New York.

of the cameras on monitors in front of him. At any given time he can take one, take two, take three, or take four and put the image on the line that is going out on the air or on the tape. So he says to camera one, "Camera one, move in for a closeup shot." He says to camera two, "Camera two, give me the left side of that face there. Okay, take two." So he takes two and he's got one waiting. He's got one in position ready for a line take. So as soon as he says to the technical director, "Take one," the technical director puts it on the line. Now, he has two other positions here, but esesntially there are not very many other positions he can take. He can take a super-impose, he can switch from one camera to the next. He can chroma-key, which means that he can take camera one's image and cut out that image with camera two and put it on the line so that the two different images appear to be in equal density, which is different from a superimposition, where the two images are sharing the in-formation space.

In superimposition, the final picture is a shared piece of imagery, 50 percent of the light per image. In chroma key, the images have divided the screen, each part uses 100 per cent of the light. Super-imposition is light-sharing. Chroma key is time-sharing.

Another thing the director can do is to dissolve one image into another image. That is not as common as it used to be because we have now gotten to a state where television has a formalized appear-ance. In the 1950s and 1960s dissolves and that kind of thing were very popular. Now they're almost always limited to rock concerts. What you get now are clean-cut permutations, 1-2-3-4. And that again is a timing device. It acts the way counting time acts. We keep it on a person for one second, the next person for a second, then we switch back for two seconds. The audience sees it as a way of counting time.

One of the crucial issues of television is the analytical view that the audience has of the imagery. In other words, what it is they think they're seeing when they see it. There are a number of ex-pressions for image quality. Most commonly we say that something is "live." You've heard that expression. "The live television broad-cast." Which means exactly what it says. It's happening in the same moment that you're looking at it. We have another expression, which is to say that it is "live analysis." Which means that the analytical view that the audience has of the experience is that it appears to be

Les Levine: *Brainwash*. 1974. Color, with sound, 30 mins. Courtesy Anna Canepa Video Distribution, Inc., New York.

live. It appears to be happening in the same time they're watching it. Of course it is not happening in the same time or it would not be called live analysis. It would be called live. Live is considered the most desirable, and live analysis is the second most desirable, and the least desirable of all is what we call "theatrical analysis." By theatrical analysis we mean that you have the understanding when you watch the screen that you're not seeing it at the same time that it was produced. The process itself has some history to it. The way a film has a history to it. The idea that you are watching something that was made to be watched at twenty-four frames per second and is now seen as sixty bit parts per second changes the way you perceive it. You are not seeing sixty bit parts per second. What you are seeing is twenty-four frames in the time space of sixty bit parts per second.

Television is an incidental light system. We are looking directly into something that generates light as though looking into a light bulb. The goal of all information seems to be to generate heat without actually causing burn. Without causing a bad signal-to-noise ratio. With film if you try to find a way to make it generate more heat, you burn the film or you wash it out, because you're dealing with something that is physical. However, with television you're dealing with phosphors. These phosphors can be heated up. If you look into a light bulb and all of a sudden the electricity goes up or down one watt, it's like an extraordinary flash, an extraordinary direct piece of information. Light is information. Light is necessary for perception, unless you're talking about the kind of information that comes out of a relationship of the body to surfaces, such as feeling things.

The thing that makes us consider what is live and what is analytical is time base. Time is the instrument that causes us to perceive the image to be live, live analysis, or theatrical. The reason live analysis is considered to be the cream of television is because it creates believability more than any other form of television. If you see it happening on your screen in real time, you believe that it really is happening. An analytical sense of liveness means that it has the appearance that it's happening now. The mind can, by creating some kind of analytical view, make it appear to be happening now.

In the theatrical situation, where it's a film or a badly technically

produced video tape, you have a grid of media between you and the image. It doesn't seem as clear. It doesn't seem as sharp. It doesn't seem as bright, and so you have the feeling that perhaps you're looking at an antique. You're looking at something through something else. The appearance is not firsthand. So you will discount believability. You will think that is just entertainment that doesn't matter, it's not real. These terms were arrived at because of certain developments in TV that we call time-base analysis. The ability to look at a picture and tell whether the timing of the picture is off or not. In other words, the capability of the machine to make the picture in the correct amount of time it was supposed to be made. Manufacturers have produced a machine called a time-base corrector.

A picture in perfect timing on TV is called a square picture. We say that the picture is square. We mean the quality of the picture is square. That it is pulled tightly in all directions, that there is no flutter. No wow or flag waving in the picture. If a picture is not square, if it's fluttering, we will assume it to be one of two things. Either it's a timing error or it's an error in the horizontal sync. If it is an error in the horizontal sync, it probably cannot be corrected. The recorder that made it needs repairs. If it is a timing error, we can put it in a time-base corrector. The time-base corrector will strip off all the timing information on the tape and reinsert new timing information that will make the picture perfectly square.

Everything in television is done electronically, editing is done electronically. It is a nonphysical medium. I think that any nonphysical medium is more pervasive than a physical medium. Sooner or later a physical medium gets caught in the problem of being a thing. TV has more "is-ness" than "thing-ness." Television reads itself for you. So what occurs in TV is that the physical body, the "thing-ness," has been removed, and a direct connection between mind and mind is made possible.

A good TV producer tries to erase entirely the space that the viewers are living in. The TV program has got to pull the viewers' minds out of their own living space and pull them into TV space. Now they are in the air. Floating the same way that the TV signal is. A TV producer understands that what he has to do is to get the viewer inside that TV set mentally. It has to seem to be happening directly in your mind. TV is the most direct form of mind-to-mind

Les Levine: *Bum*. 1965. Black & white, with sound, 50 mins. Courtesy
Anna Canepa Video Distribution, Inc., New York. Photograph: Jim de
Sana.

communication that has been developed so far. Ideas can be expressed without the necessity of having a physical object in the space. So the artist is trying to deal with a medium that is more directly connected with the mind than objects are.

But the artist finds himself in a peculiar position, because this medium is controlled by big business. So the average artist is forced to work with simplistic tools. Portapak, the one-gun camera, sometimes no color. The average television program requires a staff of thirty to produce: writers, set designers, lighting people, sound men, graphic designers, etc. In the average video tape made by an artist, all of these functions must be done by the artist himself. An average half hour of network television costs about $300,000 to produce. The cost of a prime-time television commercial is about $100,000. So you can see that as the time gets shorter, the cost per minute goes up, way up, because it takes the same staff and equipment to produce one minute as it takes to produce a half hour. As a matter of fact, it takes about the same amount of time, too. The art viewer is always asking, why can't video artists make their video tape like real TV? The first answer is they simply don't want to. They are trying to use TV to express art ideas instead of simply to sell products, the most common use of brodcast TV. The second answer is they don't have the budgets, the staff, or the equipment to produce broadcast-quality television. Many of the ideas in artists' video tapes are far more interesting than broadcast TV, but they suffer from a lack of technical support. As a matter of fact, broadcast TV has not had a new idea in years. But they have learned how to produce rubbish with amazing style and production. This glossy, technical style prevents the audience from seeing that everything on TV is a rerun of everything else on TV. It is clear now that the prime purpose of broadcast TV is to deliver the masses to the giant corporations who have products to sell. To do this, they employ all kinds of creative people: actors, singers, dancers, and so on, and turn these theatrical artists into salesmen and saleswomen for their products. Of course, by coopting the treatrical artists, they remove their artistic freedom and make them company men and women: replacing door-to-door salesmen with actors on TV. It seems obvious that the video artist does not want to become a company man. He or she wants to remain an artist and to have the autonomy to express art concerns that are generated from some internal concept of reality

rather than being generated from a memo from the company's president.

Television is mass media. Video art applies only to those interested in art, much in the same way as there might be specialized programs for those interested in boat building, stamp collecting, group therapy, and so on. The video cassette has made it possible to produce programs for audiences of less than ten thousand economically, implying a whole new area of specialization almost akin to specialized trade magazines.

Video art in the long run is not television. It's the medium of television being used by artists to express conceptual ideas and also to express ideas about time and space. What is important about video tape is that it is a direct medium of dealing with your own mind, not making a physical object that puts your body between you and your mind. The tendency of video tape is to expose the artist in a direct relationship with the audience. The audience knows how the artist feels, knows how the artist is thinking at firsthand, for the first time in the history of art.

It's only been within the past year or two that artists have had access to so-called professional-type equipment. Most artists have used half-inch equipment. But half-inch equipment could not broadcast, because it couldn't be processed. In the past two or three years the availability of processing amplifiers (proc amps) opened up half-inch video to broadcast television. Previously, half-inch equipment was not broadcastable and nobody would have considered it to be broadcastable because technically everybody would have shuddered at the thought of putting half-inch video out on the air.

There are standards set by the broadcast industry called the EIA standards. The exact meaning is Electronics Institute of America. The standards are designed to hold certain parameters for stability and color saturation so that uniformity is held from program to program. Extensive equipment is needed to meet the criteria of EIA. Somewhere in the neighborhood of $16,000 worth of equipment to take a half-inch video recording and bring it up to broadcast stability.

The tape format of half-inch video equipment is described as EIAJ. It's the format agreed upon among the Japanese manufacturers and not the North American manufacturers. What we mean by format is the way the signal is recorded on the video tape and

the speed of the video tape. For example, a roll of tape that was recorded on a Panasonic machine could be played on a Sony machine. But it's not to be confused with the EIA standards.

Just to clear that up, EIAJ applies to a standard of tape format. EIA applies to a synchronization format. EIAJ means that the tape records in the same way as other tape machines that are also EIAJ. But that doesn't mean that it can be broadcast.

So most of the half-inch, or so-called consumer-type, video products, which are also educational-type products, are not broadcast products. And they can't be used in any over-the-air systems without being proc-amped and time-base-corrected.

Quad broadcast video recording is four rotary heads that are exactly parallel to the recording tape. Each head records one full line of a TV image or a full video picture frame.

Most helical scan information is not sufficient to go on the air no matter what format it's produced in. Whether it's half-inch, quarter-inch, or one-inch. Not because of the number of heads, but because of the basic instability of the recording machines.

When you try to put a helical scan signal into the air, it could be received by the home viewer's TV set, but there would be problems, such as flag waving at the top of the screen. We would have color shifts. The hue wouldn't be correct at all. Maybe the picture wouldn't even lock up on the screen. Almost any type of problem can exist.

You can transmit almost any type of signal. There's no problem at that end of the system. The home TV sets are really the basic problem. On the half-inch Portapak-type equipment, there is not sufficient information on the tape for the home user's television set to be able to process the picture correctly.

That is a function purely of the fact that the tape is a half-inch helical scan tape, and the sync is being supplied by the alternating current. There's no input of raw information as sync.

Very rarely do you ever lose vertical hold on your TV set. But you always see the picture move around horizontally. Home TV sets lock vertically to the power AC line. But as far as the horizontal signals go, there are no true references for the set to lock up to.

Now with three-quarter-inch cassettes, the signal-to-noise ratio is much higher than any recorder in the past. Their stability is a lot better than half-inch recorders. But they still contain a large error,

and that's why we have to use a time-base corrector to make up for these inaccuracies.

Some three-quarter-inch cassette machines have built-in processing amplifiers and drop-out compensators. Their prime function is to straighten out anything that's inaccurate. If there's a piece of information missing on the tape, the compensators will fill it in. The new processing amplifiers will actually strip out the old sync and reinsert new sync that is perfectly timed, perfectly shaped. It won't make up for a time-base instability, but it will give you new sync pulse. So if you have an inadequate amount of sync or too much sync, it will take care of that problem.

A time-base corrector is somewhat like a clock, in a very broad sense, in that it keeps perfect time. It makes sure the tape information is passing the playback head at a precise and accurate speed. It does this by controlling the recorder's motors, helping it speed up and slow down. The time-base corrector actually memorizes every line of the picture. In short, it takes apart the whole picture and reintegrates the whole picture with a new sync pulse—with all things perfect. So it's actually a memory stage system, or a small computer.

Why does a video tape machine need to have such an accurate sense of time? If we compare it to an audio tape recorder, all the same problems exist in audio that are present in a video tape recorder, except in video you see it. Sight is more critical than sound. If your audio recorder is slightly out of time, it will simply sound as if the person was speaking slower or faster or slightly garbled. But if your video recorder is slightly out of time, the picture will be garbled or scrambled or flag-waving or not absolutely square or all of those things.

I've always found with video processing amplifiers that the final image is always a trade-off. If you want to increase the stability of a picture, you have to put it through a series of electronics so that in many cases your picture becomes more stable, but it also becomes snowier or it becomes striped in some way or the color shifts a bit or something like that occurs. Because what you end up with is not a live video picture but a processed video picture, almost like a reconstituted picture. You've taken the picture apart and then you've remade the picture electronically, so that it doesn't have the same liveness to it, it's dead looking.

Artists have to meet EIA standards so they can do good editing,

so they can go into multigeneration copies, and that's a must whether they're even considering going on network or not. They still have to meet these specifications if they want their tapes shown in a variety of places.

The weak spot of all video tape is the edit point. If there's going to be any degradation of the tape or the image, it's likely to happen where the editing occurs. Because that's where the most electronics meet with the greatest amount of force. We suddenly have to erase information and reinsert new information in the exact same spot on the tape, which we know is almost impossible to do and yet we expect a video tape recorder to do it with ease.

It seems to me on first sight that the one-gun color camera has a greater capability to revolutionize the so-called video industry than any other new video product. Time-based correctors and proc amps correct certain kinds of problems, but those problems can be over-come to some degree by using a better recorder, using a better signal. The one-gun camera cuts down the size of the camera to allow for small remote operations that were not previously possible, because most three-gun cameras—three-video-tube cameras—which is what they're normally called, require a lot of setting up; they're large, they're heavy, they don't really apply themselves to remote outdoor operations. Just to warm up the tubes and operate them the power requirement is horrendous. Color video is something that's super-critical. The power supply to feed it has to be extremely stable. We take for granted the power that comes out of the walls as electricity, but it's an extremely stable device. That's the reason that our clocks keep time at home, because our clocks run by the frequency of the power line and not the voltage.

Once you get into batteries, you're becoming more unstable, and the higher the power requirement, of course, the greater the prob-lems and the more sophisticated the electronics have to become.

The whole concept of Portapaks originally was a one-gun concept, because all the black-and-white Portapaks have one-gun cameras. They didn't have to be any more than one-gun because they were only producing black and white. Now there are a number of com-panies that are producing one-gun color cameras that are no heavier or more complicated than the previous Portapak black-and-white cameras.

It seems quite obvious that the miniaturization of television

cameras, the concept of portability for outdoor production with television cameras, and the processing of images to stand up in the air are all going to happen. It is happening now to some degree. TV stations don't have any choice when it comes to fast, instant, up-to-date and low-cost news. Portable video is the only way to go. The day of film is over for TV news.

The thing that will speed this process is the fact that the one-gun camera by its nature produces a different kind of image. It produces a live image. It gives the feeling that a person is there. Even though the actual technical quality may be somewhat low, the one-gun camera has a higher live analysis than the so-called studio camera, which has more liveness than film. But the three-gun studio camera is static, it doesn't move, it doesn't seem to have a body sensibility the way the one-gun camera seems to have a body sensibility. The one-gun camera seems to move with the body, and that definitely has some effect on the look of TV images.

I think that anything on a television screen is more convincing. The colors, especially when you get outdoors, when you start look-ing at the beautiful greens. They can be as synthetic as all hell, be the wrong shade all together, but on TV they look much better, more real. TV really convinces.

Color TV seems similar to the concept of the electron microscope. When we had ordinary microscopes, we thought we could see certain kinds of things very clearly. As soon as we developed an electron microscope—something not only to see through but actually to energize the image to some degree—then suddenly we realized that we hadn't seen what was there at all. We had seen only the surface. The electron microscope made it possible to go below the surface and monitor reality. Maybe television is just a better moni-toring system. Because of TV we can see ourselves better now than before.

EPISTEMOLOGICAL TV

RICHARD LORBER

All but one of the artists discussed in this essay came to the field of video art through the more traditional forms, such as sculpture, painting, and film. The exception is Peter Campus, who came from a career in commercial television. In discussing Campus's video artworks, Lorber finds an artist both "unpredictable and interesting in multiple aspects of the medium."

Richard Lorber teaches art history at Parsons School of Design, has written for several art journals, and is editor of the performing arts journal Dance Scope. *As a video artist, he has most recently been working with dancers toward an electronic fusion of figurative imagery and conceptual abstraction.*

It now seems that this phase in our cultural evolution will be ever more shaped by new communications media. Appropriately enough for the "antennae of the race," our artists are responding to electronic technologies. Just now, video, in particular, is orbiting the arts. But only a few visual artists have as yet synergistically developed the resources of the medium in the making of video art.

Understandably, it was the visual artist who awakened early to the unexpected possibilities of video as an art medium. It has already been a decade since half-inch portable videotape recorders were first available and acquired by a handful of artists. Considering the aesthetic impasse then of Abstract Expressionist conventions, it's not surprising that some of these individuals saw the canvas ultimately replaced by the cathode-ray tube; others anticipated (and still do) that film and the traditional materials of sculpture would be similarly supplanted. And now many latter-day pop, minimal, environmental, and conceptual artists, most of whom already had

95

done away with the canvas and other traditional material supports by other means, have also opted to work in video. There were practical and in some cases cynically commercial reasons for this. Nevertheless, as these artists began seeking support structures for their work in systems of ideas outside of formal aesthetics, the instrumentality of video became ever more amenable. The dematerialized immediacy of the video monitor image and the medium's reflexive properties in live feedback systems have tended to make video art something of a "final solution" for handling all the epistemological and perceptual ironies (harking back to Marcel Duchamp) in the art of the last ten years.

In this electronic phase of aesthetic retooling, some artists have concentrated on the technological development of the medium in the interests of expanded sensory effects. Nam June Paik, Woody and Steina Vasulka, Bill and Louise Etra, among others, have built and used synthesizers, colorizers, and other impressively conceived machines to induce new octaves of visual phenomena, heightening the sensuosity of the video image and warming up a decidedly cool medium. Other artists have collaborated with television stations, using available technology in experimental broadcasts (usually closed circuit) and in live two-way feedback projects reaching a wider public (Douglas Davis and James Seawright, to mention a couple). Their work seems intended to stimulate and rehabilitate the advanced technology that has generally lain dormant in the conventions of commercial TV. Both groupings of artists seem committed to closing the gap between the aesthetic possibilities inherent in the hardware of commercial TV and the modes of thinking prevalent in the software of video art.

By far the greatest number of video artists are, in a sense, poachers on the medium, although welcome ones. To scratch the surface of a list of diversely prominent artists, one could cite Robert Morris, Bruce Nauman, Les Levine, Lynda Benglis, Keith Sonnier, Nancy Holt, Richard Serra, Joan Jonas, Dan Graham, Dennis Oppenheim, Vito Acconci, Amy Greenfield, John Baldessari, Ed Emshwiller, as artists *also* working in video, although it is becoming all-consuming in several cases. As Douglas Davis has noted, these artists often tend to use video as "another studio tool to impose upon video ideas generated in other conditions." Camera/monitor systems may serve as responsive feedback components activated by the

viewers' perceptions of their own presences in an environmental event. Or, camera/monitor relationships may add an objectivizing, apperceptive dimension to a live performance piece. In many ways recent video work has been an integrating catalyst for holistic inter-media art forms. Alternately or additionally, many of the same artists make "closed" video tapes, where the processes of the medium are less apparent.

Unfortunately, a specific accounting of who in the above group does what, and what that is, is beyond the scope of this article. And this collation intentionally excludes those individuals who have emerged preeminently as video artists—seemingly born to the medium. Here the sparest sampling would have to recognize Frank Gillette, Douglas Davis, Shigeko Kubota, Ira Schneider, William Wegman, and Peter Campus. This last artist, although typical of the group only in terms of his initiative, is perhaps the most unpredictable and interesting in multiple aspects of the medium and can thus bear exemplary scrutiny.

Of all the video artists here discussed, Campus is, incidentally or significantly, the only one who abandoned a burgeoning career in commercial television (assistant producer of two TV series) to work as a professional video artist, beginning only in 1970. Nor did Campus come to TV with an art background, but rather as a student of psychology with some work in film. Curiously, Campus is equally at home with the environmental adaptations of live video as well as the making of very finished video tapes of a high order of technical and aesthetic sophistication. Two of his earliest works point up a consistency of intention within contrasting modalities.

In the video tapes collectively labeled *Dynamic Field Series* (1971) Campus systematically investigates the relativism of perception. For one segment he has attached a portable video camera to a rope hung from a pulley on the ceiling of a gymnasium. By first hoisting, then lowering the camera, and keeping himself within the focus, the artist recedes and draws nearer, diminishes and enlarges, in a vertiginously vertical space. As though viewing a kite flyer from the kite's point of view, the camera registers its own physical movement in the visible transformation of the monitor field. Campus's other manipulations of and operations upon the video camera create similarly self-regulating "dynamic fields." These video tapes exterior-

Peter Campus: *East-Ended Tape*. 1976. Color, with sound, 8 mins., 30 secs. Courtesy Castelli-Sonnabend Tapes and Films, New York. Photograph: Bevan Davies.

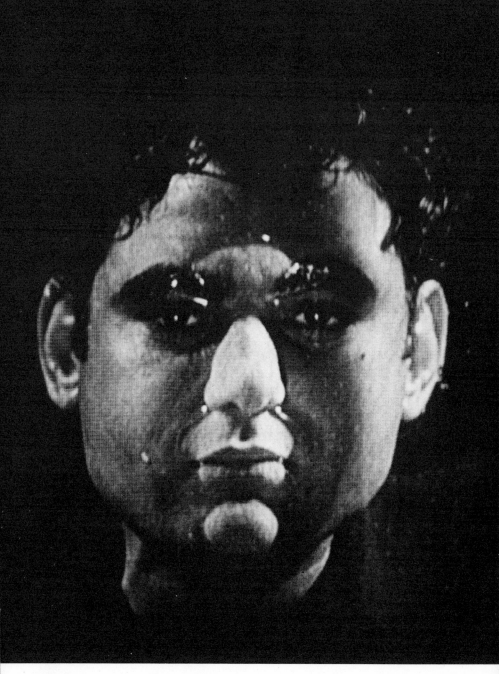

Peter Campus: *Third Tape*. 1976. Color, with sound, 5 mins. Courtesy Castelli-Sonnabend Tapes and Films, New York. Photograph: Bevan Davies.

ize ambiguous visual and kinaesthetic relationships, synthesizing an
objective perception of the artists' subjective experience. The
viewer's vision of space is transformed relative to the artist's actions
in that space.

What might be thought of as an environmental incarnation of the
same concept, *Kiva* (also 1971), consisted of a live video camera
mounted atop a connected monitor with rotating mirrors suspended
in front of the camera eye. Campus described the piece as "an
extension of the room, an object defined in space, acting on the
space. It generates a continuously changing perspective, a sum of
views from points fixed in space and time." At the Whitney Biennial
this work did, indeed, fascinate spectators, who saw themselves
cubistically knitted into the room. Their intermittent, fragmented
screen appearances were determined by the orbit and eclipse of
mirrors in relation to the viewers' movements in space and time.
Inclusion and exclusion by the camera eye became a dynamic warp
and woof on the monitor field. With simplicity transcending gim-
mickry, *Kiva* fused the viewers' two-dimensional pictorial percep-
tion of themselves and their tactile awareness of three-dimensional
space.

In a subsequent color video tape, Campus encapsulated his earlier
live and taped perceptual investigations in rather more of a philo-
sophical paradox. Like a trio of visual koans, the *Three Transitions*
(1973) confront the viewer with systematic inversions of the ex-
pectation of video as an objectively realistic, truth-telling visual
medium.

In the first and most startling "transition," Campus stands with
his back to the viewer, facing close up to a wall. In a sudden con-
stricted action, he jabs a knife through the wall. Tearing into it as
though it were cardboard, the knife also miraculously pokes out
through his back. Slicing down the wall and down his back, inward
and outward simultaneously, Campus then pushes in the ripped
wall and a congruent flap opens out his back. He ducks under the
flap, stepping into the opening in the wall while also emerging
face-forward toward the viewer through the flap in his own back—
literally going inside-out of himself. The illusionistic use of the
medium is highly convincing, suggesting a kind of corporeal palin-
drome. (The illusion is created through the carefully registered
superimposition of video images recorded on both sides of the wall.)

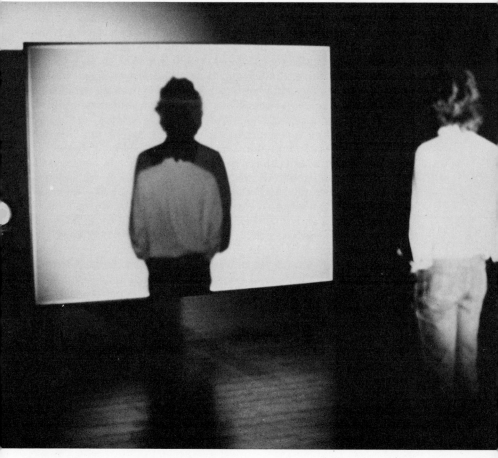

Peter Campus: *Shadow Projection*. 1974. Installation Castelli-Sonnabend Gallery, New York. Courtesy Castelli-Sonnabend Tapes and Films, New York. Photograph: Christopher Coughlan.

In his equally magical second "transition," Campus erases his face
to reveal the same nose, chin, lips, forehead—the identical image,
slightly off-register, under the original. A mask is thus peeled away
to expose an ironic "reality" beneath. For the third "transition,"
Campus totally annihilates his face. We see a shot of his hand hold-
ing what looks like a photograph. Only as he sets it aflame do we
notice the twitchings of living facial features—it is an electronically
transposed image of his actual face at that moment, appearing to
burn up in his hand.

Three Transitions dramatizes the essential nature and central
paradox of the video medium. The viewer's awareness of the proc-
esses and possibilities of the medium is heightened and concretized
the more the verisimilitude of the subject is transformed and de-
materialized. Campus uses the "convincingness" of the medium
against itself to perpetrate a kind of double reverse on the real. Such
deadpan "documentation" of a triad of impossibilities aims at an
irony that will shatter faith in subjective perception. The artist's
matter-of-fact betrayal of the TV viewer's expectation of an auto-
matically lifelike illusion, through the same technology, generates
inescapable contradictions of perception and cognition, vision and
thought.

A final word: While some other video work rivals the inventive-
ness of the Campus oeuvre, and while other artists come to other
terms with the psychological meta-aesthetic (reflexiveness, objec-
tivization, and immediacy) of the medium, the majority are locked
in "rearview-mirror-thinking," as McLuhan calls it. They content
themselves with the expediency of video to transmit concepts de-
rived from other media systems. Perhaps for this reason video art
as such is still in incubation. Only the video anomaly today will
exacerbate the viewer's consciousness to the point of admitting a
vision of the future for this very visionary art.

VIDEO ART, THE IMAGINARY AND THE *PAROLE VIDE*

STUART MARSHALL

"Video is produced within another space and the viewer is always on the outside looking in," writes the composer and artist Stuart Marshall. Starting with ideas on Symbolic order proposed by the French psychoanalyst Jacques Lacan, Marshall concentrates on the notion of imagery, the "distance" separating the viewer from the operational realities of video (as opposed to cinema in which the viewer is placed between the projector and the screen) and the advantages of video's "instant playback" capability.

In these notes Marshall probes the nature of the video medium and strives to identify some of the special (and hitherto unidentified) peculiarities of the video mode. He concludes that "the situation in which the [video] tape is seen obviously plays an important part in the way the tape functions as an object of voyeurism . . ."

Marshall reveals that, in video, "the artist confronts both equipment and image of the self, and it is at this point that the curiosity of the artist about the medium becomes subverted into a curiosity about the relationship of the subject to its representations." Thus, according to Marshall, "This constant lure of the discourse of the medium . . . poses problems for artists and theorists alike." Such problems are the central concern of this article.

The relations between this *Homo psychologicus* and the machines he uses are very striking, and this is especially so in the case of the motor car. We get the impression that his relationship to this machine is so very intimate that it is almost as if the two were actually conjoined—its mechanical defects and breakdowns often parallel his

neurotic symptoms. Its emotional significance for him comes from the
fact that it exteriorizes the protective shell of his ego . . .
 —Jacques Lacan[1]

It is surprising that although video was hailed in quasi-cybernetic
eulogy as the most important new medium to be appropriated by
artists, it has suddenly found itself with few places to go. If video
art is in a state of malaise (which I tend to think it is), it is for a
variety of reasons. The problem of accessibility has to be a central
one for artists, galleries, gallery alternatives, and the art audience
alike. Seven or eight years after artists' video tapes were first pro-
duced, very few people have seen the tapes or installations that they
have been able to read about at length. Although one should differ-
entiate between the situations in Europe and the U.S., this observa-
tion does seem generally to hold true.

The situation is undoubtedly complex, involving the economics
of the art world, the politics of television, and the paucity of theory,
but also affecting the work of many artists themselves. Their dis-
course becomes more solipsistic as the predicted video distribution
channels fail to materialize, and certain galleries with the money
and the inclination to provide viewing rooms and taping facilities
monopolize more of the action. It should be noted that British tele-
vision has been particularly resistant to this infringement on its
medium in comparison with the television companies of Holland,
West Germany, and the U.S. (not including the networks), which
have shown several "amateur" video tapes.

My intention is not to establish quite who is to blame if the video
artist ends up talking to him/herself, but rather to point to the
effects that such repression can have when applied to a medium
with a decidedly solipsistic pull of its own. If the artist does not
literally end up in a situation of monologue, the technology itself
can function as a barricade, a kind of externalized ego, hiding the
artist's alienation by providing situations (installations) in which
the audience members can become engrossed in their own alienation
as objects of their own consciousness.

The dearth of theoretical work on video beyond the level of

[1] "Some Reflections on the Ego," *International Journal of PsychoAnalysis,* 34
(1953), pp. 11–17. (Address to the British Psychoanalytical Society, May 22,
1953.)

description is probably excusable in the light of the medium's inaccessibility, but it results in a difficulty in identifying with a collective praxis. Many people (myself included) disagree with even the simplest categorization of video work into: "recorded performance," "installation," "community/political," and "video art proper" (whatever that might be).[2] With a lack of references, history, or shared objectives, it is predictable that artists begin from the deceptively benign artist/video equipment confrontation, not only in an attempt to discover what they can do with the medium but also to discover just what the medium does to them. This elementary configuration consists of a video camera connected to a video recorder, which is in turn connected to a video monitor providing the live camera view. The possibility of feedback suggests itself immediately: the camera views the monitor and a regression of monitors appears within the monitor. Tautology has been a mainstay of video art, and although reflexivity has characterized much of the art of the 1960s and 1970s, nowhere has it appeared as frequently as in video.

If the elementary artist/video equipment confrontation results in the medium acting as its own object, the most obvious redeployment takes the form of the medium acting as a feedback system enabling the artist to become an object of his/her own consciousness. Here the artist confronts both equipment and image of the self, and it is at this point that the curiosity of the artist about the medium becomes subverted into a curiosity about the relationship of the subject to its representations. This constant lure of the discourse of the medium will be the central concern of this article. It poses problems for artists and theorists alike.

Many theories of a medium attempt to isolate a particular mode of signification, a relation between the signifier and the signified appropriate to that medium alone. (Consider the art-school criticism of "literariness" leveled at a painter.) I limit my approach to the video signifier not in an attempt to "reveal" a "matched" signified, but rather to suggest why an infatuation with the signifier leads to an inter- and intrasubjective conflict so often evident in video art. "And one will fail to even keep the question in view as long as one has not got rid of the illusion that the signifier answers to the function of representing the signified, or better, that the signifier

[2] See, for example, Allan Kaprow, "Video Art: Old Wine, New Bottle," *Artforum* (June 1974).

has to answer for its existence in the name of any signification whatsoever."[3] This is not a nosographic approach, or an explication of psychoanalytic theory.

Recent work on a psychoanalytic theory of film appears to be applicable to video, several articles about which have apeared in *Screen* magazine, notably Christian Metz's "Imaginary Signifier."[4] The augmentation of semiotic theory by psychoanalytic theory has revitalized semiotics after a certain impasse, its value having been recognized by the Tel Quel group in Paris, who have paid particular attention to the Freudian tradition as presented by the aphoristic and hermetic work of Jacques Lacan of the École Freudienne. In an article in the *Times Literary Supplement* Julia Kristeva presented her notion of semanalysis:

> The theory of meaning now stands at a cross-roads: either it will remain an attempt at formalising meaning systems by increasing sophistication of the logico-mathematical tools which enable it to formulate models on the basis of a conception (already rather dated) of meaning as the act of a *transcendental ego*, cut off from its body, its unconscious and also its history; or else it will attune itself to the theory of the speaking subject as a divided subject (conscious/unconscious) and go on to attempt to specify the types of operation characteristic of the two sides of this split; thereby exposing them to those forces extraneous to the logic of the systematic; exposing them, that is to say, on the one hand, to bio-physiological processes (themselves already inescapably part of the signifying processes; what Freud labelled "drives"), and, on the other hand, to social constraints (family structures, modes of production, etc.).

The semiotic tradition now referred to as classical semiotics has in this case shifted emphasis from the transcendental subject toward the divided subject and the transgression of systematicity.

The application of psychoanalytic theory to a signifying practice hinges on notions of the subject's construction in language and the

[3] Jacques Lacan, "The Insistence of the Letter in the Unconscious," in *Structuralism*, ed. Jacques Ehrman (New York: Anchor Books, 1970), p. 106.
[4] *Screen* magazine, 16, no. 2 (Summer 1975).

positions that the subject is assigned in order to be produced as the support of meaning. It is in this sense that Lacan has claimed to have produced a materialist theory of subjectivity. His work constitutes a vitriolic attack on the authenticity of the Cogito and idealist and nominalist theories of meaning. Dismissing the notion of the unified fully present subject manipulating a world of meaning, which by preexisting the signifier simply waits to be named, he has argued for a theory of the subject's construction in and by language but always eccentric to the symbolic systems that include it. The subject is never the intending transcendental subject, but rather is absent, only being produced as an effect of the signifying chain. The establishment of the positionality necessary to constitute the identity of the speaking subject within sociality is achieved through the registers of the Imaginary and the Symbolic.

Lacan first presented the "mirror phase" and the Imaginary order as a psychoanalytic "stage" at the International Congress of Psychoanalysis at Marienbad in 1949. The most readily available account of the mirror phase, Lacan's "The Mirror-Phase as Formative of the Function of the I," was published in *New Left Review 51* (1968). Citing work by Charlotte Bühler, Elsa Köhler, and the Chicago school of psychology on transitivism, Lacan proposes a dramatic event that takes place between the ages of six and eighteen months in the form of a primary identification with the image of the self. He describes a situation in which the child in a state of dependency (lack of motor coordination) and incomplete neurophysiological development (the result of what Lacan terms "a specific prematurity of birth") perceives itself as a gestalt in a mirror, as a harmonic and unified image of an anticipated maturation. The ego is consequently precipitated as an Imaginary construct, as an identification with a specular image which is other. This fundamental misrecognition alienates the subject in its own image and an oscillation inheres in which the self is always an other and the other is always the self. This prototypical object positions the subject in relation to its representations and begins the work of separation through which the subject constitutes a world of objects and its relation to an "outside," and hence the threshold of signification. Prior to this moment the child has been dominated by the drives, which will be reorganized by, but will traverse the Imaginary structure. The oscillation that structures the relationship between

subject and other guarantees a unity and coherence that is charac-
teristic of the Imaginary. Laplanche and Pontalis in "The Language
of Psycho-Analysis" suggest that the Imaginary involves "a sort of
coalescence of the signifier with the signified."

It was the discovery of narcissism that led Freud to postulate a
stage between autoeroticism (the satisfaction of a component in-
stinct without resort to an external object) and object love proper.
In this stage the subject "begins by taking himself, his own body, as
his love object."[5] Freud links the birth of narcissism with the forma-
tion of the ego (in order that it be taken as love object)—the taking
place of "a new psychical action,"[6] and with the neurophysiological
development of the cerebral cortex, the "cortical mirror." The rela-
tions among the ego, narcissism, notions of selfhood, and the consti-
tution of the bodily schema are all tied together in the primary
identification of the mirror phase as the internalization of a rivalrous
relationship. The identification with and introjection of the self as
other marks the emergence of narcissism (secondary narcissism in
the later Freud).

The Imaginary relation forms the model for the later identifica-
tions contributive to the formation of the ego ideal (which allows
for the continuance of the ego's self-interest) and those narcissistic
object choices termed secondary identifications. It is important to
stress that it is an image and an ideal exhibiting Imaginary co-
herence and unity based on the relationship of subject to ego that
serves as a model for such identifications. Secondary identifications
are therefore characterized by the narcissistic structure of the identi-
fication and misrecognition of other as self.

It is the Imaginary that begins the construction of the subject, the
precipitation of the *je* from a state of undifferentiated asubjectivity
dominated by the drives. But the relation set up between the sub-
ject and its representations is a locking into an illusory unity, a
totalization that holds the subject outside of process and contradic-
tion. This fiction of the subject is only disintegrated in the entry into
the Symbolic when the dual subject/image relation is challenged by

[5] "Psycho-Analytic Notes on an Autobiographical Account of a Case of Para-
noia" (1911), in *The Complete Psychological Works of Sigmund Freud* (*Stand-
ard Edition*), ed. James Strachey, 24 vols. (London: Hogarth Press, 1953),
XII, pp. 60–61.
[6] "On Narcissism: an Introduction," 1914, *SE*, XIV, pp. 75–76.

the necessity of the subject's production in relation to a third term: the Other. In order to take its place as speaking subject, the child must be subjected to (constructed by) the order of difference that is language. In his extension of the diacritical theory of meaning (which proposes that the meaning of any signifier is only established in a differential relation to all other signifiers) Lacan links the birth of the unconscious with the establishment of the Other place that will guarantee meaning. Hence: "The unconscious is the discourse of the Other." Concomitant with the birth of the unconscious is the production of unconscious desire by language itself. It is desire that will always exceed the subject and will introduce the lack (*manque à être*) for which no object is adequate.

It is no coincidence that Althusser describes ideology in terms of imaginary relations to systems of representation. In that the production of meaning demands that the subject be produced in a position that will support that meaning, the subject can be most securely fixed to it through the unificatory structure of the Imaginary. It is the Imaginary relation that constructs the metaphysical transcendental subject, synonymous with the predications of consciousness. The interarticulation of ideology and the Imaginary denies the unconscious and the work that is the production of meaning.

The video system is a very new and different mirror that not only presents a nonreversed image of the self but also allows for an observation of the self that is not spatially fixed (one sees one's image from a place where one is not looking) or temporally fixed (the tape-delay installation). Video's extraordinary power lies in this novelty and it is this function of image return specific to the medium that persists as a model for intersubjective relations in many video works. Artists frequently refer to video as a mirror: "You search your approach in the mirror for some truth about how you appear in the world."[7]

"Here is an example showing how a video tape, used as a mirror, becomes necessary too. It would have been impractical to film such a situation with a movie camera, since the presence of a cameraman would have been embarrassing."[8]

Mirrors frequently appear in video tapes, not only demonstrating

[7] Eleanor Antin, "Dialogue with a Medium," *Art-Rite*, 7 (1974).
[8] Jean Dupuy, "The Diphthong I," *ibid.*

Lynda Benglis: *Collage*. 1973. Color, with sound, 9 mins., 35 secs. Courtesy Castelli-Sonnabend Tapes and Films, New York.

this dialogue with the self but also constituting a metaphor for the duality of self, as witnessed in the taping session when the image being taped is available on a monitor. Cameras and mixers equipped with mirror-reversal and image-combination facilities allow for the making of complex electronic mirrors, where a present self interacts with the image of one or many "past" selves. The examples are numerous, including: *Duet* (1972) by Joan Jonas, in which the artist howls at her prerecorded monitor image, and *Left Side, Right Side* (1972), which explores the relations between video's nonreversed image and the mirror's reversed image; Vito Acconci's *Centers* (1971), in which the artist points at his own monitor image, and *Recording Studio from Air Time* (1973), in which he attempts to view himself as another by looking in a mirror, "seeing himself" in the same way that the woman he is thinking about does; Lynda Benglis's *On Screen* (1972), *Document* (1972), and *Now* (1973), which all involve the interaction of many layers of self-portraits; and Hermine Freed's *Two Faces* (1973), in which Freed confronts her own image.

Video's possibility of instant playback, in comparison with the long delays of film processing, has been remarked upon repeatedly by artists as being an important factor in their work, and it would not seem too extreme to describe this quality of image return as having the "insidious capturing effect" (captation) described by Lacan as appropriate to the mirror phase. The closed-circuit television installation offers the paradigm video/mirror experience. The image of the spectator is displaced and repositioned, appearing and disappearing on monitors and in video projections around the space. Contemplative object of consciousness, the image of the self, tied to the conscious experience of the body yet detached from its physicality, floats in impossible places, performs impossible movements, and entrances the viewer with a miraculous new other that is self. The video technology rearticulates the mirror's moment endowing this other with an illusory autonomy; perhaps as it is approached, the image walks away or reappears in an other place.

The installation places the viewer as source and object of a world of vision created for and by him/her. A reduced and enclosed world of objects is produced for the subject in the image of the ego, which was originally an other. "Thus this *Gestalt* . . . is pregnant with the correspondences which unite the I with . . . the automaton in

which, in an ambiguous relation, the world of his fabrication tends to find completion."[9] To describe this situation as narcissistic is not to use the term in a vague qualitative sense but to point to the actual intersubjective structures that the technology reproduces in its structure. The idealized body image takes on the significance of the master image, which is the self-aggrandizement of the subject.

Such notions of self-examination are not peculiar to video art. The psychotherapeutic use of video in its complicity with ego psychology makes claims for the acquisition of a heightened self-awareness through this rituallike repetition of the mirror's moment.

The Imaginary describes the intersubjective structure of identification in terms of the structuration of looking. The subject sees his/herself as the object of his/her look while constituting him/herself as the object of the look of the other self. For the Imaginary structure of looking to be reproduced in video, it is necessary that the subject should identify with the other one who is also looking, which is to say identify with the camera. The camera looks in a certain way (its look is articulated). Modeled on perspective projection and revealing a certain ideology of notions of space, the camera places the subject in its identification with it as the transcendent source of a coherent world of vision that has been "brought into place." That such an identification must take place in the viewing of the tape or installation is the condition of the image's comprehensibility. To recognize what is seen is here to misrecognize in the mode of the camera's look. It is this fundamental misrecognition, describable in terms of the Imaginary structure, that will articulate the misrecognition of the image of the self as other. In every sense one can say that the camera constitutes the look for the subject and in that constitution positions the subject.

In video art the camera is very often stationary; either fixed in the installation or "left to run" in the tape because its making involves the artist alone working as a performer. The immobility of the camera mimics the motor immaturity of the child entranced before the mirror—rooted to the spot.

> Unable as yet to walk, or even to stand up, and narrowly confined as he is within some support, human or artificial, . . . he nevertheless surmounts, in a flutter of jubilant activity, the obstructions of his

[9] *New Left Review*, 51 (1968).

support in order to fix his attitude in a more or less leaning-forward
position, and bring back an instantaneous aspect of the image to hold
it in his gaze.[10]

In the tape, the identification with the immobile camera is intensified
by the artist's personification of it. It is addressed directly, enter-
tained (its eye is kept from straying), and performed in front of.
The artist's identification with the camera (the mirror model of
intersubjectivity) requires that s/he offer him/herself as object to
the other s/he constructs in the image of the self. Communication
with the absent other consequently becomes modeled on the rela-
tionship with the present other. The other that is spectator is con-
structed in the place of the other that is alter ego, and it is this place
that is allotted to the viewer.

DRIVE, DESIRE, AND PARANOIA

If the structures of identification and idealization initiate the con-
struction of a world of objects, they also articulate the drives. The
video tape is an object of the drive to see (scopophilia) and the
drive to hear (pulsion invocante), the former being one of the com-
ponent sexual drives described in the "Three Essays on the Theory
of Sexuality,"[11] where each drive is assigned a specific source. In
"Instincts and their Vicissitudes"[12] Freud is concerned with demon-
strating how a component drive can be transformed, and he dis-
tinguishes the autoerotic drives from those that are from the begin-
ning directed toward the object. These include sadism (its source
being the musculature) and scopophilia (its source being the eye).
It is only this latter type of drive that can be modified by a "reversal
into the opposite"—the reversal of sadism into masochism and
voyeurism into exhibitionism, both involving a change of object,
the "turning around upon the subject's own self." To describe this
situation as narcissistic is to point to the actual intersubjective struc-
ture that the technology reproduces in its structure. According to
Freud, the sadomasochistic relationship consisted of a dialectic of
activity and passivity, identification with the other transforming

10 *Ibid.*
11 S.E., VII, p. 125.
12 *Ibid.*, XIV, p. 111.

sadism into masochism and vice versa.[13] This relationship of drive
to phantasized identification is articulated by the movements and
displacements of desire.[14]

So far it has been suggested that the Imaginary sets up a coher-

[13] *Ibid.*, VII, p. 159.

[14] The relation between drive, desire, and the object has a complex history.
The Freudian term *Trieb* introduced in the "Three Essays on Sexuality" has
frequently been translated as *instinct;* but although it is a bioenergetic concept
with the sense of "heaving" or "pressure," it has little to do with "instinct" as
behavior determined by heredity. (*Trieb* is hereafter translated as *drive.*) In
"Instincts and their Vicissitudes" Freud also introduced the terms *source, aim,*
and *object.* Freud describes the sexual drive as labile denying the specificity of
its aim (sexual union) and its source (the genitals) as commonly thought. The
sexual drive is said to consist of component drives (polymorphous perversity),
associated with various erotogenic zones (sources) only later to be organized
and assigned to one erotogenic zone and a particular mode of object relation
that is determined by the subject's history. (The early aim of the component
drive is the release of somatic tension at the source.) The sexual drives are
distinguished from the drives of self-preservation by the specificity of the latter's
aim and objects (e.g. hunger—food). The sexual drives are accommodating with
respect to their aims and objects. Later work distinguishes the part object from
the love object by associating the former with its closer relation to drive and
direct satisfaction, and by associating the latter with its relation to the total ego.
The term *wunsch,* usually translated as *wish* or *desire,* is described in the theory
of dreams in the following manner. Need (drive) achieves satisfaction through
a specific object (e.g. food). The experience of this satisfaction becomes a
mnemic image associated with the memory trace of the need's excitation. When
the need reoccurs, the mnemic image is recathected, evoking the perception of
the earlier satisfaction. The wish is consequently bound to the memory trace,
and attempts to satisfy it result in a hallucinatory reproduction of the earlier
perception (phantasy). The object of the wish is consequently bound to the
signs that constitute it.

Lacan uses a genetic viewpoint of the object relation in the mirror phase, and
his later work on a "logique du signifiant" is concerned with the child's earliest
relations to objects. The early theory is more or less a re-presentation of the
Hegelian theory of desire, as the desire for the object of the other's desire, and
here the object is "l'autre." The "logique du signifiant" develops the Kleinian
theory of the part object and establishes a relation with "l'objet a" at a much
more primordial stage. The part object is a symbolic object mediating the rela-
tions between mother and child. For the object to be constituted it must be
discovered to be absent or lacking, and from this time the satisfaction of need
does not do away with what has become the memory of the need and the lacked
object. The part object therefore conveys a lack, and its importance in the
genesis of desire is stressed in "La Relation d'objet et les structures freudiennes"
(*Bulletin de Psychologie,* XI/1, September 1957, pp. 31–34). Lacan interprets

ence that is enduring and unthreatened. Lacan's genetic account of subject construction describes the fracturing of the Imaginary by language's introduction of desire on the entry into the Symbolic. In that there is no video spectator who is before the Symbolic and the positionality of language, there is no Imaginary for him/her that is untroubled by desire. Hence there is no possibility of a "pure" repetition of primary identification. The Imaginary regression must attempt to arrest the movement of desire, fill the lacks that it poses, or constrain it in an idealized object and so recapture it.

Lacan's theory relates the paranoid psychoses to the structure of aggressivity that is the term of the Imaginary relation. This aggressivity, which is Imaginary alienation, is the condition of the construction of the world of objects that are modeled on the object that is the alienated ego.[15] Unconscious desire triggers the aggressivity of the Imaginary. In his doctoral thesis Lacan demonstrated that the persecutors of a young paranoiac were identical to the images of the ego ideal (for which the ideal ego of the mirror phase is a precursor).

the early speech sounds of Freud's grandson as re-presenting the earlier discovery of the opposition of presence and absence by means of phonological oppositions. The lack of object becomes the gap in the chain of signifiers that the subject attempts to fill at the level of the signifier. "It is the connection between signifier and signifier which alone permits the elision in which the signifier inserts the lack of being into the object relation, using the reverberating character of meaning to invest it with the desire aimed at the very lack it supports" ("The Insistence of the Letter in the Unconscious").

Consequently discourse becomes a movement toward something and is as governed by the lack, as is desire. The upshot of this reworking of the theory of desire is the distinction between need, demand, and desire. Desire is "an effect in the subject of that condition which is imposed upon him by the existence of the discourse, to make his need pass through the defiles of the signifier" ("Direction of the Cure"). The acquisition of language allows for the conscious demand (ultimately for love), which is to be distinguished from need in that its object is nonessential. Unconscious desire as a lack that cannot be filled is engendered by the detouring of need (which can be satisfied) through demand (which cannot). Desire is introduced into being by language itself, lies out of consciousness (unconscious), and is irreducible to an object of need (its recognition constitutes the "cure").

[15] Truth is not Knowledge but recognition, mental "illness" being a refusal to recognize truth. Human knowledge is "paranoiac," "it constitutes the ego and objects under attributes of permanence, identity and substantiality, in short as entities or 'things' . . ." (J. Lacan, "L'Aggressivité en Psychanalyse," in *Ecrits*, Paris: Le Seuil, 1966, p. 104).

The relationship seeing/being seen can be described in terms of the voyeuristic/exhibitionistic perversions. Proper to the scopophilic drive is the vicissitude of reversal into the opposite involving a phantasy identification with the object, a reversal of activity and passivity, and the inversion of roles. For the video artist observing him/herself on the monitor, there is a narcissistic identification with the body image (a withdrawal of object cathexis and a surging of ego cathexis) and an oscillation of exhibitionism and voyeurism as s/he is placed as both subject and object of the look. Coupled with this is a phantasy identification with the absent spectator as alter ego for whom s/he is an object of voyeurism. Unlike the film actor who behaves as if no one were looking (and in this sense is not exhibitionistic), the artist frequently appeals to the other who s/he models on the image of the one s/he sees before him/her. In this sense the artist is exhibitionistic, but exhibits him/herself to someone who is missing at the time. The peculiar mixture of presence and absence that is spectator as other institutes the lack that threatens the stability of the Imaginary structure. The aggressivity triggered by this rupture articulates the subject/object dialectic with the identifications of the sadomasochistic reversal that overlay and reinforce the identifications of the voyeuristic/exhibitionistic relation. Placing him/herself as subject of the look by identification with the other, the artist places him/herself as object of the aggression that s/he as object of the look has directed outward toward the other whose desire the system cannot take into account. The whole system consequently pitches in an attempt to hold in place the absent spectator as Imaginary other. The aggressivity of the challenged structure reveals itself in the subject's positioning of itself as object of the attack—the paranoia that is the term of the Imaginary's fracture.

Step into the spotlight, that's where you belong . . . like a little dog, jump up, beg . . . you need me, you have to depend on me . . . yes, my little dancing bear, now you're there where I used to be. I don't have to be there anymore . . . wiggle your prick, now it's your turn, you'll play the fool for them now . . . you'll show them you're stronger than they are, that's what I couldn't do, you won't betray how much you hate them.[16]

[16] From the text of the video tape, *Command Performance* (1974), by Vito Acconci.

It is this complex play of activity, passivity, and phantasy identification proper to the reversals of sadomasochism and voyeurism/exhibitionism that also describes the identifications of the spectator. So many tapes appear to have been made in the privacy of the artist's studio, where the intruding (yet welcome) camera places the viewer in his/her identification with it as counterpart and threat in the position of the artist's "hallucinated" ego ideal, present now but absent then. This identification with the staring camera assigns the viewer the role of voyeur—ultimately a position of sadism—identification with the artist placing him/her in a position of masochism. The artist addresses the viewer, acts as though s/he was present, then attempts to seal the spatiotemporal recording distance with this Imaginary relation of looking and being looked at, yet the spectator is presented with an absent object whose presence has been delegated to the tape recorder.

LIZA BÉAR: Do you want to keep a distance between you and the audience?

VITO ACCONCI: Yeah. (*Sounds doubtful.*)

LB: Or do you want to change the relationship?

VA: It's more that I want the relationship to be changed, but I'm not sure how . . . I think I mean something like this: I want the ground for these pieces to be contact between me and passersby, but I want to change the mode of my presence. That's why there's been an urge recently to leave out actual performance. I want my presence to become so unfocused that contact with it becomes difficult . . . rather, so that physical contact with me becomes almost a false problem.[17]

This lack, which is the spatiotemporal recording distance, is symbolized by the gap between subject and object that voyeurism maintains. Video through its lack of definition and limited screen size maintains the most fixed viewing distance of any time/space art form. Unlike film, which places the viewer within the space activated between the image producer (projector) and the screen, video is produced within another space and the viewer is always on the outside looking in. If the image is approached, it disintegrates into a blurring of electronics, as an object of desire it is properly elusive. This lack of definition becomes a titillation, a play with visual iden-

[17] Vito Acconci, "Fragile as a Sparrow but Tough," interview with Liza Béar, *Avalanche* (May 1974).

Vito Acconci: *Face Off*. 1972. Black & white, with sound, 30 mins. Courtesy Castelli-Sonnabend Tapes and Films, New York.

tification, the look and the object. As a recording, video's lifetime is short and every play brings it closer to its eventual disintegration into electronic noise.

The situation in which the tape is seen obviously plays an important part in the way the tape functions as an object of voyeurism for the audience member. It is interesting that the lighting conditions necessary for the making and viewing of video tape almost reverse those for filming. Filming requires high levels of lighting whereas projection requires darkness; video taping often takes place in low lighting conditions but can be viewed in a brightly lit room. Video tapes are in fact usually shown in a dimly lit room, probably in an attempt to deemphasize the monitor (a most anomalous object), but unfortunately reminiscent of 1950s-style television viewing. The connotations of the sitting room, the paradigm viewing situation of the television image, cause video artists enormous anxieties (which a regression of images of the monitor can only amplify). And artists have become most devisive in their attempts to prevent these connotations foregrounding.

Vito Acconci has been particularly aware of these "problems," and has achieved a high level of medium transparency by constructing unusual viewing situations and engrossing the audience member in a seductively direct discourse. In an installation version of *Command Performance*, shown at 112 Greene Street, New York, in January 1974, Acconci positioned a video monitor showing a prerecorded tape on the floor in front of a spotlit stool. The seated spectator's image was transferred live by means of a camera to a monitor behind him/her, in front of which a seating rug provided a viewing position for other audience members. In this configuration the single spectator watching the tape is placed in a position similar to Acconci's when the prerecorded tape was made, he/she literally being "in the spotlight." The viewing situation consequently draws the spectator into the work, in that he/she becomes an object of voyeurism for other spectators in the same way that Acconci is an object of voyeurism for him/her.

There is an onus on the video artist to address him/herself to the ideology of systems of representation. If I have devoted this paper to the myth of transcendental subject, it is because much video work reinforces and reproduces this myth in its viewing structures. It is

the work of the Imaginary to place the subject in a fictional coherence that fixes the subject to its self-delusory images. Signification is a work and a process based on the establishment of position in contradiction and difference. It is the business of the artist to pose the subject in process as the site of the dialectic that is inherent in signification.

VIDEA, VIDIOT, VIDEOLOGY

NAM JUNE PAIK with CHARLOTTE MOORMAN

Nam June Paik was one of the first artists to concentrate on the video medium. In collaboration with Charlotte Moorman, Paik's works have been performed widely and frequently both in America, Europe, and Australia.

The following notes, some by Paik and some by other writers, were originally printed over a time span of almost fifteen years; the most recent was published in 1976. They document some of Paik's video works and, more importantly, offer a glimpse into Paik's highly original thoughts concerning video.

Venice is the most advanced city of the world . . . it has already abolished automobiles.
—John Cage in an Italian TV interview, 1958

Someday Walter Cronkite will come on the screen and say only one word and leave: "There is nothing new under the sun. Good night, Chet!!" . . . 29 minutes of blank and silence. . . .

From Marx to Spengler, from Tolstoy to Tocqueville, not a single prophet of the recent past predicted the greatest problem of today . . . parking.

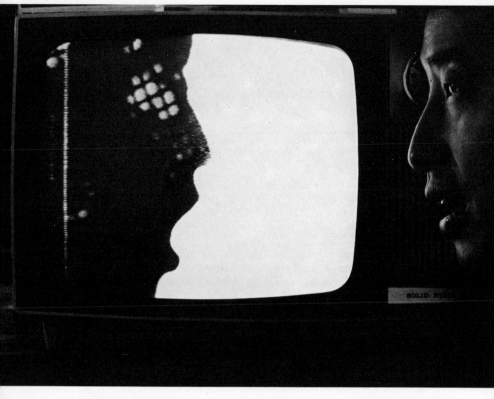

Nam June Paik: *Self-Portrait,* with "video commune." 1970. Color, 3 hrs.
Produced by WGBH-TV. Photograph: Eric Kroll.

Vietnam war is the first war fought by computer
 and
 the first war lost by American.

Nietzsche said hundred years ago . . . "God is dead." I say now
"Paper is dead . . . except for toilet paper." If Joyce lived today,
surely he would have written his Finnegan's Wake on video tape,
because of the vast possibility for manipulation in magnetic informa-
tion storage.

 This argument is settled for good.
 TV commercials have all three.

Radio Free Europe is interesting and informative, but the noise,
which jams that station is also interesting and informative . . . en-
joy both. Jam your TV station and make it "Radio Free America."

 Marshall McBird says . . . "Wind is moving the flag."
 Marshall McButterfly says . . . "Flag is moving the wind."
 Marshall McLuhan says . . . "Your mind is moving."

 Plato thought the word, or the conceptual, expresses the deepest
thing.
 St. Augustine thought the sound, or the audible, expresses the
deepest thing.
 Spinoza thought the vision, or the visible, expresses the deepest
thing.

ABSTRACT TIME

PAUL SCHIMMEL: Could you tell me about your relation with Char-
lotte Moorman? You did make TV Bra (1969), TV Cello (1971),
and TV Bed (1972) for her.
 NAM JUNE PAIK: I consider her to be a great video artist. Video art
is not just a TV screen and tape—it is a whole life, a new way of life.
The TV screen on her *body* is literally the *embody*ment of *live video
art.*
 PS: She becomes video.

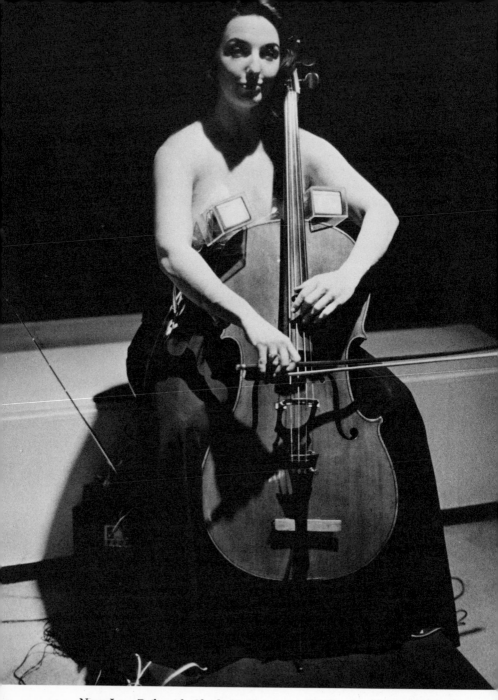

Nam June Paik with Charlotte Moorman: *TV Bra for Living Sculpture*.
1969. Courtesy Howard Wise Gallery, New York. Photograph: Gilles
Larrain.

NJP: *TV Bra* and *TV Cello* are interesting because Charlotte did it. If any other lady cellist did it, it would have been just a gimmick. Charlotte's renowned breast symbolizes the agony and achievement of the avant-garde for the past ten years. When given a choice between *truth* and *convenience,* people always choose *convenience.* Both artists and distributors are concentrating on video-tape-making, which is more *convenient,* whereas my live video art with Charlotte is expensive, clumsy, and, as an art object, almost unsalable— like a piece of *truth.* It is about time that we make the distinction between video art and videotaped art.

PS: How would you relate your *Train Bra* (1973) with your *TV Bra?*

NJP: The pair of two bras shows us the way to solve the energy crisis and our current inflation-depression. I wish Charlotte had been invited by President Ford to attend the economic summit meeting at the White House. Transportation and communication are generally considered as two separate issues; however, we should ask *why* people travel. People travel to *communicate* something, either for pleasure or profit. In the case of pleasure driving, they are subconsciously communicating with themselves *via machine,* since few have the courage to scrutinize their inner selves. Tireless indulgence into video feedbacks by some video artists have the same motives. The frequency of travel will reduce if the need to travel is reduced. What we need is a substitute technology to travel. Here the role of video artists as the pioneer-experimenters in telecommunication-transportation trade-offs is great. Charlotte Moorman showed us this impending conversion in the most elegant way, by adorning herself with *TV Bra* and *Train Bra.*

PS: What is the meaning of your *TV Bed* for Charlotte Moorman, then?

NJP: I have been working for TELE-FUCK for a long time. I sent the following letter to Billy Klüver in 1965, which was printed in the New York Collection for Stockholm (Moderna Museet).

Someday more elaborated scanning system and something similar to matrix circuit and rectangle modulations system in color TV will enable us to send much more information at single carrier band, f.i. audio, video, pulse, temperature, moisture, pressure of your body

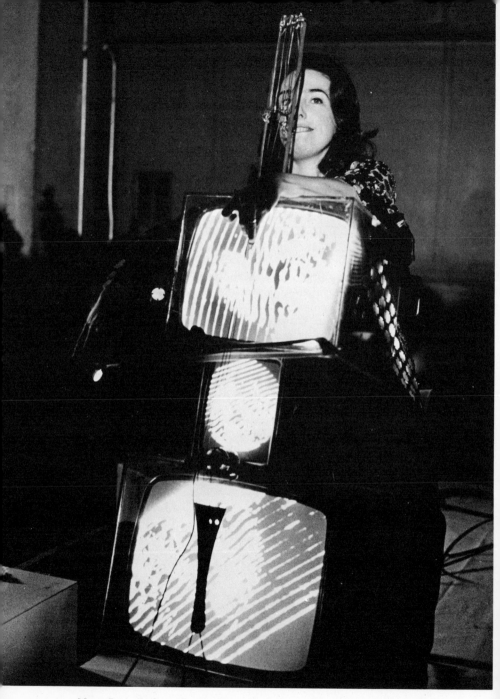

Nam June Paik with Charlotte Moorman: *Concerto for TV Cello and Videotapes*. 1971. Courtesy Bonino Gallery, New York. Photograph: Eric Kroll.

combined. If combined with robot made of rubber, form expandable-
shrinkable cathode-ray tube, and if it is "une petite robotine" . . .

please, tele-fuck!

with your lover in RIO.

1965

Global promiscuity is the easiest guarantee for the world peace. If
100 top Americans have their tele-fuck-mates in U.S.S.R. (100 top
Russians' wives), we can sleep a little bit safer. Video art is an art
of social engagement, because it deals with energy and peace.

ps: Within the content of your video pieces, there seems to be an
interface between ritual-classical tradition and the modern popular
culture. Why is this?

njp: I like John Cage because he took seriousness out of serious
art. There is no difference between ritual, classical, high art and low,
mass entertainment, and art. I *live*—whatever I like, I take.

ps: You come to video from music, whereas many video artists
came from painting-sculpture. What is the difference?

njp: I think I understand time better than the video artists who
came from painting-sculpture. Music is the manipulation of time.
All music forms have different structures and buildup. As painters
understand abstract *space*, I understand abstract *time*.

ps: Do you think your video will ever have mass appeal?

njp: I couldn't care less about it. I enjoy my video. If people like
it, that is their problem. This is why I sleep every Monday until
1:00 p.m. to show the world that I am independent. I am lazy. I tell
everybody not to call me on Monday.

ps: That way you don't have to wear double-knits and go to work.
Did you ever have a steady job?

njp: No, not really. I just did what I thought I should be doing.

ps: And you still do that?

njp: A bum doesn't do anything he doesn't like. I do the same
thing.

ps: Do you think video as an art object will ever turn into the
public mass media mainstream, or will it remain on the fringe of
society?

njp: The demarcation line between high art and mass art is often
fuzzy, e.g., Buster Keaton and Humphrey Bogart were not consid-
ered high art in the 1930s and 1940s, but now many highbrows con-

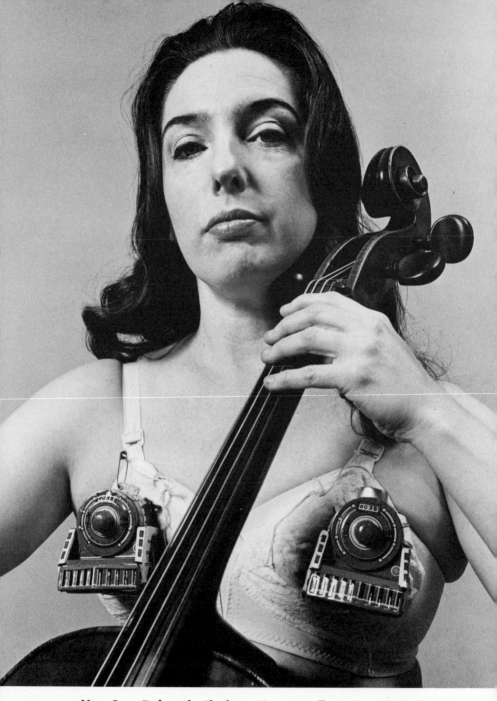

Nam June Paik with Charlotte Moorman: *Train Bra*. 1973. Courtesy
Annual Avant-Garde Festival of New York. Photograph: Eric Kroll.

sider them to be important artists. On the other hand, quite a few high art pieces, including some Picassos, are now clichés.

<div align="right">Paul Schimmel</div>

TV BRA FOR LIVING SCULPTURE (1969)
Nam June Paik—Charlotte Moorman

In this case, the sound of the cello she plays will change, modulate, regenerate the picture on her *TV BRA*.

The real issue implied in "Art and Technology" is not to make another scientific toy, but how to *humanize* the technology and the electronic medium, which is progressing rapidly—too rapidly. Progress has already outstripped ability to program. I would suggest "Silent TV Station." This is TV station for highbrows, which transmits most of time only beautiful "mood art" in the sense of "mood music." What I am aiming at is TV version of Vivaldi . . . or electronic "Compoz," to soothe every hysteric woman through air, and to calm down the nervous tension of every businessman through air. In that way "Light Art" will become a permanent asset or even collection of million people. Silent TV Station will simply be "there," not intruding on other activities . . . and being looked at exactly like a landscape . . . or beautiful bathing nude of Renoir, and in that case, everybody enjoys the "original" . . . and not a reproduction . . .

TV Brassiere for Living Sculpture (Charlotte Moorman) is also one sharp example to humanize electronics . . . and technology. By using TV as bra . . . the most intimate belonging of human beings, we will demonstrate the human use of technology, and also stimulate viewers NOT for something mean but stimulate their fantasy to look for the new, imaginative, and humanistic ways of using our technology.

1963. The following essay was written immediately after my exhibit of electronic television at Galerie Parnasse, Wuppertal, Germany in March 1963. It was printed in the June 1964 issue of the *FLUXUS* Newspaper, New York.

(1)

My experimental TV is
> not always interesting
> but
> not always uninteresting
like nature, which is beautiful,
> not because it changes beautifully,
> but simply because it changes.

The core of the beauty of nature is that the limitless QUANTITY of nature disarmed the category of QUALITY, which is used unconsciously mixed and confused with double meanings.
> 1) character
> 2) value.

In my experimental TV, the word *QUALITY* means only the CHARACTER, but not the VALUE.
> A is different from B,
> but not that
> A is better than B.

> Sometimes I need red apple
> Sometimes I need red lips.

(2)))

2 My experimental TV is the first ART (?), in which the "perfect crime" is possible. . . . I had put just a diode into opposite direction, and got a "waving" negative television. If my epigons do the same trick, the result will be completely the same (unlike Webern and Webern-epigons) . . . that is . . .

My TV is *NOT* the expression of my personality, but merely
> a "PHYSICAL MUSIC"

like my "FLUXUS champion contest," in which the longest-pissing-time record holder is honored with his national hymn (the first champion: F. Trowbridge. U.S.A. 59.7 seconds).

> My TV is more (?) than the art,
> or
> less (?) than the art.

I can compose something, which lies
higher (?) than my personality,
or
lower (?) than my personality.

❁ ❁ ❁

Therefore (?), perhaps therefore, the working process and the
final result has little to do and therefore, . . . by no previous
work was I so happy working as in these TV experiments.

In usual compositions, we have first the approximate vision of the
completed work (the pre-imaged ideal, or "IDEA," in the sense of
Plato). Then, the working process means the torturing endeavor
to approach to this ideal "IDEA." But in the experimental TV, the
thing is completely revised. Usually I don't, or *cannot* have any
pre-imaged VISION before working. First I seek the "WAY," of
which I cannot foresee where it leads to. The "WAY," . . . that
means, to study the circuit, to try various "FEEDBACKS," to cut
some places and feed the different waves there, to change the phase
of waves, etc., . . . whose technical details I will publish in the
next essay. . . . Anyway, what I need is approximately the same
kind of "IDEA" that American ad agency used to use, . . . just a
way or a key to something NEW. This "modern" (?) usage of
"IDEA" has not much to do with "TRUTH," "ETERNITY," "CON-
SUMMATION," "ideal IDEA," which Plato—Hegel ascribed to this
celebrated classical terminology. (*IDEA*) =
f.i.

"KUNST IST DIE ERSCHEINUNG DER IDEE."
"Art is the appearance of the idea."
(Hegel—Schiller.)

This difference should be underlined, because the *"Fetishism of
Idea"* seems to me the main critical criterion in the contemporary
art, like "Nobility and Simplicity" in the Greek art (Winckelmann),
or famous five pairs of categories of Wölfflin in Renaissance and
Baroque art.

4

INDETERMINISM and VARIABILITY is the very UNDERDE-
VELOPED parameter in the optical art, although this has been the
central problem in music for the last ten years (just as parameter
SEX is very underdeveloped in music, as opposed to literature and
optical art).

a) I utilized intensely the live-transmission of normal program,
which is the most variable optical and semantical event in 1960s.
The beauty of distorted Kennedy is different from the beauty of
football hero, or not always pretty but always stupid female an-
nouncer.

b) *Second dimension of variability.*

Thirteen sets suffered thirteen sorts of variation in their VIDEO-
HORIZONTAL-VERTICAL units. I am proud to be able to say that
all thirteen sets actually changed their inner circuits. No two sets
had the same kind of technical operation. Not one is the simple blur,
which occurs when you turn the vertical- and horizontal-control
buttons at home. I enjoyed very much the study of electronics, which
I began in 1961, and some life danger I met while working with
fifteen kilovolts. I had the luck to meet nice collaborators: HIDEO
UCHIDA (president of Uchida Radio Research Institute), a genial
avant-garde electronician, who discovered the principle of transistor
two years earlier than the Americans, and SHUYA ABE, all-mighty
politechnician, who knows that the science is more a beauty than
the logic. UCHIDA is now trying to prove the telepathy and proph-
ecy electromagnetically.

c) As the third dimension of variability, the waves from various
generators, tape recorders, and radios are fed to various points to
give different rhythms to each other. This rather old-typed beauty,
which is not essentially combined with high-frequency technique,
was easier to understand to the normal audience, maybe because it
had some humanistic aspects.

d) There are as many sorts of TV circuits as French cheese sorts.
F.i. some old models of 1952 do certain kind of variation, which
new models with automatic frequency control cannot do.

DISASTER IN NEW YORK

Nam June Paik is currently having two simultaneous exhibitions in New York galleries, and people who know something about art are saying that both of the exhibitions are disasters.

However, despite the poor receptions and confused critiques, Paik continues to offer important new ideas for video art.

Nam June Paik is a consistently confusing and irreverent artist who has been making technological and video artworks for many years. He has been closely identified with video art ever since there has been such a thing. His new exhibition of video art at the Bonino Gallery (1976) is consistent with his earlier works in that it is preposterous, serious, and quite funny indeed.

In one of his earlier exhibitions Paik designed a "video cello," *Concerto for TV Cello* (1971), for cellist Charlotte Moorman. Ms. Moorman "wore" a complex device consisting of several television monitors piled one on top of another to form a "cello" shape. Moorman also happened to be physically wired to these devices and, as she "played" her video cello of piled-up television sets, various shapes occurred on the screens of the sets. Although Moorman didn't seem worried in the least about getting electrocuted ("Paik wouldn't let that happen to me"), she frequently complained about the effects of exposure to what she called "television radiation."

In the *TV Cello* what happened was that by "playing" her instrument the performer caused images on the screens to change. Thus as performer, Ms. Moorman was directing the images on her sets. It was an extraordinary conception and a theoretical masterpiece, because instead of "being on television," the televisions were, in fact, on Charlotte Moorman.

Another work by Paik, involving Charlotte Moorman, was called *TV Bra* and was made in conjunction with a piece called *Train Bra*. The *TV Bra* consisted of two miniature television sets affixed to Moorman's breasts; the *Train Bra* was two little train engines fixed to a bra worn by Ms. Moorman, or worn by anybody else for that matter.

There is a connection between *TV Bra* and *Train Bra*. According to Paik, video artists are "pioneer-experimenters in telecommunication-transportation trade-offs," a situation illustrated ". . . in a most

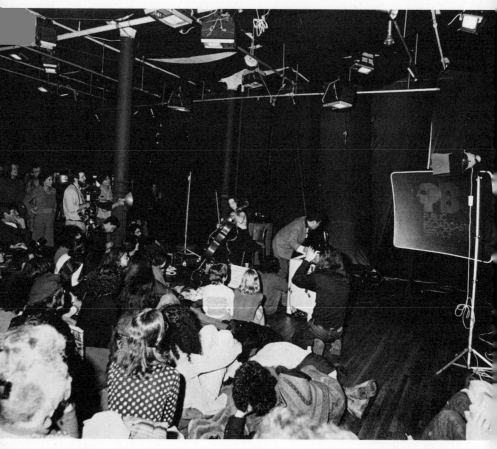

Nam June Paik: *Concerto for Heaven and Earth.* 1976. Installation Bonino Gallery, New York. Courtesy Bonino Gallery, New York. Photograph: Eric Kroll.

Nam June Paik: *Fish Flies on the Sky*. 1976. Color, with sound, 30 mins.
Courtesy Bonino Gallery, New York.

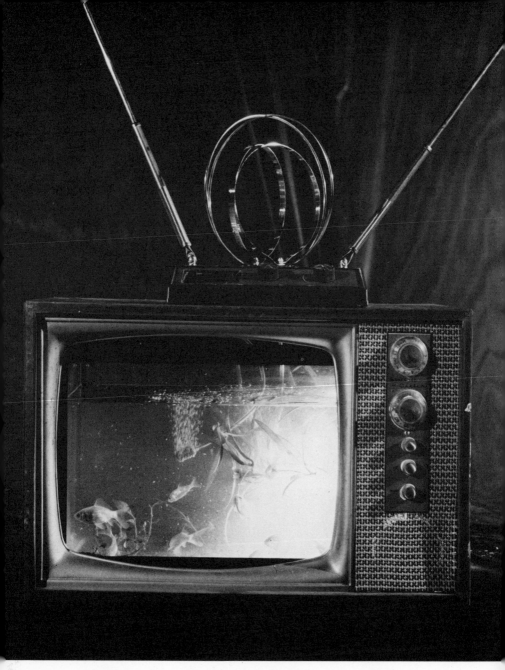

Nam June Paik: *Fish TV*. 1976. Installation Bonino Gallery, New York. Courtesy Bonino Gallery, New York. Photograph: Eric Kroll.

elegant way" by Ms. Moorman adorning herself with *TV Bra* and *Train Bra.*

The two exhibitions by Paik currently displayed in New York consist of *Moon Is the Oldest TV Set* at the René Block Gallery (in which fifteen or so television monitors each display a different stage of the moon) and a piece at the Bonino Gallery called *Fish Flies on the Sky.*

What we have at Bonino is about thirty color monitors fixed to the ceiling, face-down. Art lovers are invited to lie on the floor to get a more comfortable view of the monitors above. Thus the traditional vertical gravity-oriented top-and-bottom direction of video viewing, which has its origins in painting of the Duecento, is, for the very first time since Michelangelo attempted his Vatican ceilings, subverted.

The subversion of vertical top-bottom viewing goes hand in hand with the subversion of vertical *looking.* Modern painting, from its origins in the Duecento until the present, has relied upon a major precondition, or perhaps limitation, and that is that it be viewed from a vertical or *standing-up* position. With the change to a lying-down position, and the change in viewpoint that goes along, art, viewing, and video move significantly into a new era.

It is as though video art has discovered its relationship with highway architecture and drive-in cinema.

There are two tapes programmed on Paik's color monitors. Approximately one-half of the monitors show a tape of tropical fish swimming around. The other half show jet aircraft flying around. Thus the subject matter of both tapes may be read as metaphor for the concept of natural transportation, such as that performed by fish, and on the other hand, the concept of artificial transportation, such as that associated with all aircraft, particularly military aircraft.

Between the airplanes flying above and the fish swimming below is, of course, the surface of the water upon which boats float. And, according to Paik, the perfect video is the steamship.

Paik's metaphors concerning video experimentation and theory represent some of the most original and entertaining ideas presented through and about video art. It is, perhaps, for this reason that he is recognized as the "dean" of art video.

Gregory Battcock

A PROVISIONAL
OVERVIEW OF ARTISTS'
TELEVISION IN THE U.S.

DAVID ROSS

In this article David Ross, deputy director for television/film at the Long Beach Museum of Art, traces the recent historical development of video art in America. He sees the earliest artworks incorporating video as having been realized by Nam June Paik and Wolf Vostell, in collaboration with Karlheinz Stockhausen, at the experimental center of the West German radio network in Cologne in the 1960s.

It was the introduction by the Sony Corporation of low-price half-inch portable recording and camera equipment in 1965 that marked the beginning of the use of video by artists. Prior to 1965 "television tools were used almost exclusively by large corporations and major political parties for one-way delivery of prepackaged information."

Video art, according to Ross, allows the artist the opportunity to make "an essentially personal statement [that] can be relayed . . . in a mode that is as singular and personal . . . as face-to-face communication." Basically, Ross notes, video artists are involved in a "generalized exploration of the nature of communication."

The history of art is the history of the purpose of art.
—John Graham, 1932

The simple fact that contemporary artists are actively working with tools of television production and distribution is no longer a source of widespread bemusement. In general, making video tapes has be-
ome as common an activity as printmaking, photography, and draw-

ing. As John Baldessari said: "to have progress in TV, the medium must be as neutral as a pencil." Clearly, the advent of this kind of artmaking has provided artists with a set of tools for dealing with some of the more interesting philosophical and pragmatic problems confronting them today. Though these issues are only peripherally related to television per se, there is a real correspondence between the emerging political and aesthetic philosophies that have accompanied recent radical activity in art and mass communications.

Elie Faure, the pioneering film aesthetician writing in the 1920s, noted that film essentially constituted an architecture of movement. Perhaps it is becoming increasingly possible to see video as an architecture as well—an architecture of intention and a provisional architecture too. Its history, like that of art itself, is the history of its purpose. Television is no longer viewed as an activity of the culture but rather one that is the culture. As a result, the video work that has emerged in the past ten years has tended to reflect both a direction and mood in many ways broad and undefined.

Video allows the artist the opportunity to address a number of vital concerns in relation to the viewer. First of all, an essentially personal statement can be relayed (in a very direct way) in a mode that is as singular and personal (in scale and intensity) as face-to-face communication. Further, the time-based nature of the statement adds a captivating element to the message that the artist can either exploit (by extension over a long period of time, creating a resultant boredom/tension/release cycle) or bypass (by creating work that is immediately gratifying). In other words, the real-time consciousness of the viewer becomes the blank canvas, which can obviously be dealt with in a variety of ways. On a sociopolitical level, video is an effective and nonprecious activity aimed, primarily, at extending the range and breadth of the artists' commitment to, and relations with, the audience. The notions of a dematerialized art, which united a highly diverse group of sculptors, dancers, poets, painters, and documentarians in eclectic multimedia investigations into the nature of art, seem to have gelled into a set of activities called (fairly ineffectively) video art. Within this set, the creation of video tapes accounts for a great deal of the activity, although it is important to note that many important video works involve the sculptural manipulation of video tools themselves, live performances, or, in some instances, the manipulation of complete television sys-

tems from production to broadcasting. As coequals, working with a medium that has little traditional grounding, video artists (a term some consider derisive) find themselves involved in a generalized exploration of the nature of communication rather than the nature of the medium itself. Some artists may explore the relative qualities of illusion drawn between video and other forms of documentation, while others may work with the kind of light emitted by a television tube or with the similarities between video systems and neurological processes.

Whichever approach is adopted when working with video tape, the artist cannot ignore either the presence of the display monitor or the potential of indiscriminate anarchitectural delivery of the work to an isolated, yet comfortable and secure audience. Video works created with an understanding of the audience often seem out of place in the context of an art gallery—the works become filmic (in delivery) and their original intention is easily perverted. This is a problem that will persist until museum advocacy for this kind of artist-public communion reaches the point where it will be as commonplace for museums to have their own television channels as it is for them to house and maintain gallery spaces. Nam June Paik summed up the basis for this kind of thinking in a 1972 collage *Do You Know* (dedicated to Ray Johnson, one of the first correspondence artists). Paik added a few lines to an early 1940s magazine ad that queried: "How soon after the war will television be available for the average home?" His response becomes a leading question for the 1970s: "How soon will artists have their own TV channels?" The point to be made here is that in the midst of a deepening political, economic, and ecological crisis, we are witnessing a very real revolution in areas of communications and control—a revolution as powerful as that which followed the introduction of movable type. Communications systems have outgrown the need for mediating institutions; museums must stop translating and start transmitting. Artists have recognized their right and responsibility to create not only works of art, but the support and distribution system that serves as the context for the work as well.

I had a seven-channel childhood.
—Bill Viola, 1973

What exactly is meant by the term *video art?* We can attempt to define it as any artwork involving video tools: television cameras, video sets, videotape recorders or projectors, and a variety of image-processing devices or television systems in general. Sculptural works that make use of video tools are still primarily sculpture, dealing with spatial, temporal, and systemic problems and often with psychological and metaphysical attitudes as well. The term *video* might be applied to video tapes shown in the closed-circuit context of a museum, the commercial gallery, or a collector's home, while the same video tape shown through open-circuit transmission via broadcast or cable TV might be called television purely as the result of the basic socioeconomic difference between the two.

Though contemporaneous with the heyday of the somewhat faddist art and technology movement of the early 1960s, the origins of "video art" now seem far removed from all that activity. "Video art" did not develop only as a result of artists' fascination with the technology of video per se. It would seem rather to have resulted from the more or less random coalescence of a wider range of specific aesthetic issues that eventually led to the development of a generalized orientation away from the making of art objects.

The earliest artworks incorporating video were realized by Nam June Paik and Wolf Vostell, working in collaboration with Karlheinz Stockhausen at the experimental center of the West German radio network (WDR) in Cologne. Paik and Vostell were among a rapidly growing number of artists who brought musical and theatrical concerns with structured time and its obverse, randomness and indeterminacy, to the visual arts. These artists, who regarded Marcel Duchamp, cybernetician Norbert Wiener, and John Cage as somehow central to their concerns, formed Fluxus, a loosely knit group, in New York; it had first flourished in Europe. Paik, originally a composer/musician, began his experimentation with TV by distorting the television image mechanically, placing magnets on the screen and maladjusting components within the set itself, "preparing" the television set in an electronic analogy to Cage's prepared piano. Vostell and Paik first used prepared televisions in "de-collage" performances (Vostell's brand of Happening) late in 1959. By 1963 Paik was exhibiting his prepared televisions at the Gallery Parnasse in Wuppertal, and Vostell was displaying his own de-collaged (i.e., partially demolished) sets at New York's Smolin Gallery.

Paik himself had been in New York for barely a year when the Sony Corporation announced their intention to market a portable television camera and recorder at approximately one-twentieth the cost of all previous television-production equipment. Paik made arrangements to buy the first unit to be delivered for sale in New York, in late 1965, the same year that Marshall McLuhan published *Understanding Media.*

The situation that existed before the introduction of relatively inexpensive consumer-grade half-inch equipment was analogous to that of a culture possessing a tightly controlled radio industry and no telephone service at all. Until 1965 television tools were used almost exclusively by large corporations and major political parties for one-way delivery of prepackaged information; no provisions existed for the use of the same tools and delivery system for communications relating to the needs of the individual. The "half-inch revolution" not only led to the possibility of utilizing decentralized distribution systems such as cable TV, adapted to minority needs in a pluralistic society; it also greatly expanded the potential of video as a medium for making art.

By this time Fluxus events and the Happenings organized by artists such as Allan Kaprow, Charles Frazier, Claes Oldenburg, Robert Whitman, and Jim Dine had opened up new attitudes in American art toward interdisciplinary works, emphasizing the need for an art that was informed by the general culture as well as informing the culture. These early events in America—and in Europe and Japan during the crucial decade of 1956–66—are the precursors of most video and performance activity currently taking place in the United States.

The period from 1969 to 1970 saw the beginning of official art world recognition of artists' work in video. In late 1969, Nicholas Wilder, a Los Angeles art dealer, made the first sale of an artist's video tape in the United States—Bruce Nauman's *Video Pieces A–N* —to a European collector. In the same season, New York dealer Howard Wise (whose gallery was the home of a great deal of the kinetic art of the early 1960s) held an impressive exhibition of young video artists working in New York entitled "TV as a Creative Medium," including works by Paik, Frank Gillette, Ira Schneider, Paul Ryan, Eric Siegel, and others. In contrast to Nauman's early video work, which was an extension of his body-oriented post-

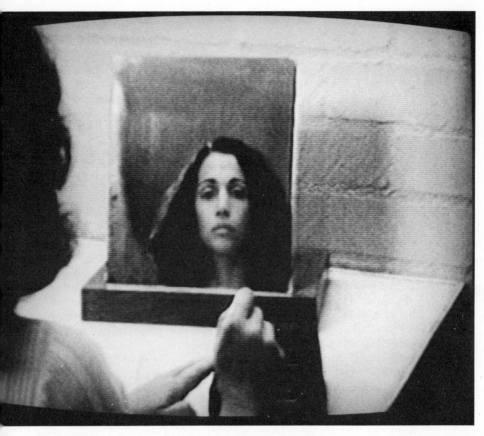

Allan Kaprow: *Rates of Exchange*. 1975. Black & white, with sound, 45 mins. Courtesy Anna Canepa Video Distribution, Inc., New York. Photograph: Harry Shunk.

minimalist sculptural activities, the works in the Wise exhibition tended to be more openly involved either with the sociopolitical aspects of television as the dominant information system or with the technical possibilities of synthesizing television images with computers and similar electronic devices. The split between those artists who were primarily involved in the relationship between art and the culture, seeing television as a way to integrate the two, and those who merely adopted these newly developed techniques as yet another tool on which the artist might draw, seemed formidable at that time. Interestingly, in the past year or so that dichotomy seems virtually to have disappeared. Many more sociologically inclined artists such as Beryl Korot have found it necessary to tighten and expand the formal elements in their work, while a more formal sculptor, Richard Serra, produced the purely didactic *Television Delivers People* in 1973.

The Wise exhibition featured one work that remains interesting to date, though not for reasons that were obvious in 1970. *Wipe Cycle,* a multimonitor work by Frank Gillette and Ira Schneider, was (as Schneider noted at the time) an attempt to "integrate the audience into the information." That integration included manipulation of the audience's sense of time and space, giving the work the combined impact of a live performance and a cybernetic sculpture. The piece consisted of a bank of nine monitors programmed into four distinct cycles including two prerecorded tape inputs, a live camera on an eight- and sixteen-second delay loop, a mix of off-the-air programs, and a unifying gray wipe that swept the field counterclockwise every few seconds. At the time, it was felt by critics like Richard Kostelanetz that the piece was an investigation into the nature of information, concerned primarily with the effect of shifting time orientation. Now the piece seems to underscore the peculiarity of the naïveté demonstrated by American video artists who saw the ability to produce video work on low-cost video equipment—divorced from any consideration of real distribution—as a revolutionary occurrence. *Wipe Cycle* can now be seen as a clear statement of the artist's continuing position well after the fact in relation to what may be television's most significant aspect and salient feature —indiscriminate transmission. Furthermore, the piece, by its elaborate structure (imitating industrial multimedia displays in form, but surpassing them in complexity) was one of the first to indicate

that in lieu of broadcast access and in consideration of the conditions imposed by the gallery, installation works involving technical capabilities of television not possible in transmission could be employed to somehow correct the out-of-placeness of television in such a loaded context.

By 1970 the first American museum exhibition of video art had been organized by Russell Connor and mounted at the Rose Art Museum of Brandeis University outside Boston. At that time, the predominant attitude of artists working with television can perhaps be summed up in a line from Gene Youngblood's *Expanded Cinema:* "contemporary artists have realized that television, for the first time in history, provides the means by which one can control the movement of information throughout the environment." Partially in response to the rapid popularization of the work of Buckminster Fuller, and partially to the emergence of ecological consciousness in general, early video work tended to reflect an emphasis on and understanding of the environmental impact and capabilities of television in the broadest sense. The Brandeis exhibition occurred almost exactly a year after Gerry Schum broadcast the film *Land Art,* inaugurating his pioneering video gallery, which was less concerned with video than it was with broadcasting primary information about artists' work directly to the home. A year later the first museum video department was established at the Everson Museum in Syracuse, New York, naming this writer as its first curator. The Everson opened a closed-circuit gallery specially designed for video viewing, and continues its series of video-oriented exhibitions, which offer a wide range of work.

The phenomenon of museum involvement with television and video came about in response to two factors: the growing interest of artists in the medium, and the growing involvement of museums themselves with social issues beyond a purely aesthetic context—an involvement that has been prompting museums to reevaluate their role as a community resource. While the Everson Museum and the Long Beach Museum of Art in California are as yet the only such institutions with separate video departments, an increasing number of museums throughout the country have had at least a fleeting relationship with television in the form of closed-circuit in-house exhibits. Several larger institutions, including The Metropolitan Museum of Art in New York and the Cleveland Museum, produce edu-

cational television based on their collections, while the Boston Museum of Fine Arts continues to produce a series of broadcast programs on art initiated in 1953.

With the exception of the new Long Beach Museum, now under construction, museums have yet to extend their involvement with television to include their own broadcast stations, or cable television systems using low-cost equipment, in an attempt to redefine the basic elements of museum architecture broadly enough to include such an obvious feature of the environment. In this respect, museums rank far behind banks and theatres, which have at least figured out how to make their architecture responsive to changes in architecture necessitated by the American dependence on the automobile.

At the 1975 conference of the American Association of Museums in Los Angeles, the issue of validating modern art was discussed at length by a panel of museum directors representing some of the most prestigious modern-art museums in Europe and America. Although they differed on many points, most seemed to agree that museums do play a significant role in validating a small segment of the vast amount of art that is produced in the world today, by giving their tacit or indirect approval of a particular artist or a specific school. The point was never made, however, that the validating process is reciprocal: Artists validate museums and galleries just as collectors do, etc., etc. The character of much recent postobject art has tended, paradoxically, to intensify the self-referential and closed nature of this system, at the same time making its tautological aspects uncomfortably clear. Though this has not led so far to any significant change in the operation of the museum/gallery/collector system, it seems increasingly probable that the art itself will somehow obviate the entire validating process. Since video, like much conceptual performance work, is essentially uncollectable, its patrons must focus on the sponsorship of inquisitive rather than acquisitive activity. The role of the museum in regard to video art may well become that of a catalyst for the development of museum-operated art-specialized television channels, as well as an immediate though temporary physical location for the exhibition of the video work of Peter Campus, Frank Gillette, Ira Schneider, Paul Kos, John Graham, et al.

If American museums are in a unique position to encourage this

Frank Gillette: *Muse*. 1973. Black & white, with sound, 26 mins. Courtesy Castelli-Sonnabend Tapes and Films, New York.

kind of "disinterested" patronage, they can also contribute substantially to the much-needed task of defining and protecting the rights of the visual artist in relationship to the rest of society. In all the other arts, the artist's prerogative to maintain some degree of control over the way his or her work is used for the commercial or political benefit of other individuals or institutions is generally accepted; these rights are even defined by law. So far as video is concerned, the rights of the artist can easily be protected by a well-written contract not substantially different from those currently used in the recording and publishing industries. As for other kinds of visual art, including more traditional, object-based forms, the particular example of video art may help to focus attention upon the problem and to provide a model for the exercise of this urgent and significant responsibility.

Most of the video work being made by artists in the U.S. today can roughly be divided into three major categories: varieties of video tape, performance pieces involving video tools either directly or as secondary material, and sculptural constructions. These seemingly clear-cut distinctions are, unfortunately, significantly blurred by the fact that many works contain elements of more than one category, with economic and other contingencies determining the nature of any particular presentation. Frank Gillette's video tape *Tidal Flats*, for instance, was installed as a part of a complex installation (*Quidditas*) that featured twelve segments of tape playing asynchronically on three distinct video systems aligned to create a montage of three congruent images in constant flux. At another time, segments were seen in a single-monitor version, when all the work was broadcast on public television. Similarly, a number of tapes are either records of performance pieces or, like Vito Acconci's *Claim Excerpts* (1973), were originally simultaneous video documentations of performances where the action was visible to the audience, within which we pigeonhole the works of artists using video tools often purely for the convenience of critical discussion, and in no way reflecting a priori decisions by the artist.

Still, it is important to remember that the physiological phenomena of television viewing play a significant role in determining the relationship between the viewer and the work. The sociological implications of a medium designed and developed for casual home-oriented serendipitous access are in a way perverted when video

tapes are shown in a public gallery space. While these sociological and psychological factors are only rarely the subject of artistic inquiry into the medium, they often bear heavily upon the artist's primary intention. This nearly inescapable distortion of intention must be acknowledged and suffered, as the ideal situation for viewing artists' video tapes is yet to come.

The same is true in relation to ownership and the noncommodity status of much video. One of the most interesting uses of video has been to extend and intensify the experiences of performance works. Compared to the ephemeral nature of performance art—apart from "residue" such as documentary material or preparatory scores—video tape may seem to be a fairly permanent record of activities and ideas. In reality, however, the shelf life of video tape, as yet undetermined, is estimated at ten to fifty years. The video image, though recapturable and in a way objectified on tape, retains its temporary nature and is thus denied the status of a precious object. Its use, as the content for a broadcast (which becomes the complete work), is that of a relegated part of the whole.

Vito Acconci is an artist who uses video in conjunction with performance. A poet of the New York School in the early and middle 1960s, Acconci became widely known at the end of that decade for his increasingly personal performance pieces, then termed "body art." His emphatic use of autobiographical information, stylized into a near-violent exploration of his physical self, has been presented both as live performances and as sculptural installations. The latter pieces normally involved some kind of prerecorded narrative information. At first this was on audio tape or film; more recently, Acconci has come to use video tape and closed-circuit video systems. Like William Wegman, Acconci works with the particularly intense and intimate relationship that can be generated between a lone television monitor and a viewer, regardless of the surrounding context or lack of context. Unlike Wegman, however, Acconci does not explore the relationship that develops. Rather does he intensify it, turning it on full blast in an effort to transfer the full intensity of the experience. In *Pryings*, one of his earliest and least verbal tapes, the artist is seen trying to force open and gain entry into any and all of the orifices of a woman's face. His persistence outlasts the running time of the tape, as does the persistence of the woman under attack,

who manages to persevere in her attempt to guard her metaphysical privacy. In later tapes Acconci developed his use of the medium's psychodramatic possibilities still further. In *Undertone,* he is able to pry into his own subconscious and at the same time monitor the viewer's concurrent prying, while *Face Off* reveals, through the artist's rather monotonous yet direct monologue, the intimacies of a sexual activity throughout the entire tape.

In a way related to Acconci, Terry Fox's *Children's Tapes* (1974) demonstrates the artist's commitment to the ritual aspects of performance, divorced from the performer's physical presence. Fox sought a way to translate his performance activities into video, maintaining the involving immediacy of the experience. He decided to follow a series of interesting, if somewhat slow-moving, tapes documenting his performances (shot by George Bolling) with a tape of his own. Fox reasoned that the taped piece might be successful if it could appeal to his young son, whose response to a televised experience was instinctive for one familiar with the medium since birth. Using much of the same symbolic lexicon present in most of his performance works, Fox created a series of active tableaux involving, among other things, a spoon, a burning candle, small bits of cloth, and a tin bowl. By interweaving these elements, Fox illustrated a series of basic scientific postulates involving balance, evaporation, expansion, and in the case of the rudimentary flytrap, a slapstick illustration of behavioral psychology. The results are amusing and engrossing, leading the viewer well beyond the literal activity to an elegant and understated view of a very private world.

Yet another relationship between performance and video is explored by Bruce Nauman, the first artist to show video tapes in an exhibition in the U.S. In *Lip Sync,* Nauman, like Acconci, used his own body as primary material for the creation of a gestalt, attempting to link the sculptural tradition to the phenomenological aspects of avant-garde dance and related body-movement work. This sixty-minute tape, originally presented at the Nicholas Wilder Gallery in Los Angeles playing continuously on a monitor mounted on top of a sculpture pedestal, was not necessarily meant to be viewed from start to finish, but could be approached and contemplated as a sculptural object. Clearly, Nauman was not unaware of the time-based nature of the medium, nor did he decline to explore the effect

Terry Fox: *Children's Tapes*. 1974. Black & white, with sound, 30 mins.
Courtesy Anna Canepa Video Distribution, Inc., New York. Photograph:
Harry Shunk.

Bruce Nauman: *Tony Sinking into the Floor* (faceup and facedown). 1973. Color, with sound, 60 mins. Courtesy Castelli-Sonnabend Tapes and Films, New York.

of time upon perception, for such exploration is implicit in the situation he established. Rather, he wanted to avoid connections with the theatricality of film showings and to break away from the rigid, structured relationships implied in that approach. Performance, sculptural installation, and the making of a self-contained video tape are all components of the work, which juxtaposes two entirely different temporal frames of reference.

Time is consistently the most difficult element for video artists to deal with. Short of creating a series of closed loops, as Ira Schneider did in his environmental video installation *Manhattan Is an Island*, the artist's choice is to use short or long periods of time that are either acknowledged and dealt with, acknowledged and left alone, or not acknowledged at all. In Schneider's *Manhattan*, the artist arranged a series of monitors in a topological configuration outlining Manhattan Island. One tape, played on the perimeter monitors, shows a view of the island from a tour boat circling the city, while another grouping added material shot on the streets uptown, etc. The effect of the piece was a complex landscape study containing not only a feel for the madness of the urban crush, but a sense of the city's metabolism as well.

In the video tape *Vertical Roll*, Joan Jonas presents not just a tape of a tape of a performance, but records the image of that tape on a playback monitor—the playback undergoing a slow vertical roll. The tape thus contains a continuous circumstance, the playback roll, within a specific time frame, creating a kind of temporal topography. The acknowledgment of time in this work is both disturbing, in that it jars the sense of propriety in the visual image, and reassuring, in that it provides a steady, rhythmic measure that underscores the viewing experience.

Paul McCarthy's taped performance works, in the tradition of Nitsch's Orgy-Mystery Theatre, allow the viewer access to a sensibility that needs the removal with retained intimacy that video is able to provide. In works like *Sauce* and *Glass* the viewer is given immediate access to relived psychotic episodes that deliver an intensity much more easily apprehended in the safety of the televiewing context.

Similarly, the one-to-one video space allows a kind of immersion to occur that heightens the bone-bare reductive elements of a Richard Landry work like *Quad Suite*—a tape focusing in a four-way

split screen on the lips and fingers of a Landry flute piece, double-tracked in stereo video and audio. In curious contrast, Charlemagne Palestine's videotaped performance works *Body Music I* and *Body Music II* (both produced in Florence at Art/Tapes/22) illustrate how an intensity can be generated by the integration of the camera into the core of the work rather than establishing the camera eye as a neutral observer to the action. In *Body Music II*, Palestine transformed what in *Body Work I* reached the viewer as the observation of an observer's view by locating the camera within his own action—literally extending his eye to include the viewer as well.

In contrast, Nancy Holt (*Underscan*, 1974), and Beryl Korot and Ira Schneider (*Fourth of July in Saugerties*), employ a traditional literary arrangement to portray differing points in historical time. The basis of Holt's work is a recollection of family history, while Korot and Schneider (coeditors of the alternative media journal *Radical Software*) have borrowed from the kino-eye theories of early Russian revolutionary filmmakers like Dziga Vertov, investigating aspects of video reality in relationship to real time and place —in this case, the experience of a patriotic celebration in a small town two hours north of New York City.

It is interesting to note that in multiple-monitor works like Beryl Korot's *Dachau 1974*, where a short real-time activity is separated into four time strands and then rewoven with the precision of a complex weaving, the artists are once again dealing with the fact that the work is being shown in a gallery situation closer to theatricality (in its publicness) than television should be. This underscores the curiously sculptural qualities that the television set assumes when taken out of the normative home context.

Paul Kos, a San Francisco artist closely associated with video installation work, created *Cymbals/Symbols: Pilot Butte* at the De Young Museum in San Francisco. In this piece, Kos integrated the soundtrack of the piece (at one point the pun: "There are tiny sounds in the desert; there aren't any sounds in the desert") with a pair of tin sheets that had been rigged to act as loudspeakers. The tin speakers literally and figuratively completed the wordplay, and in a real sense served to materialize the notion of opposition at work.

In his most recent work, *Tokyo Rose* (1975–76), Kos again extends the field of his tape by surrounding it with a sculptural context that uses the television image as bait to lure and capture the viewer.

Nancy Holt: *Underscan.* 1974. Black & white, with sound, 8 mins. Courtesy Castelli-Sonnabend Tapes and Films, New York.

Marlene and Paul Kos: *Tokyo Rose*. 1975–76. Black & white, with sound, 11 mins., 10 secs. Courtesy Castelli-Sonnabend Tapes and Films, New York. Photograph: Paul Kos.

Approaching a large mesh cage lit from angles so oblique that one can hardly see inside, the viewer hears a droning seductive voice (Marlene Kos, the work's coauthor) coaxing: "you can't resist," "come in," etc. Once inside, you see her face, taped behind a screen on which flies land and take off, still enticing the viewer in sensual rhythmic cadence to give up, stay with her, etc. Beyond the obvious play of screen/material and screen/video, the combination works in a way like Nauman's screen room to heighten the viewer's sense of place and passive condition in relation to the work itself.

Juan Downey's multiple-channel works that comprise his "Video Trans Americas" series are built from tapes edited to be played simultaneously in pairs. Structured with incredible precision, works like Nazca, Inca, and Cuzco develop temporal harmonies and displacements within the stereo organization, leading the viewer through an active experience of real-time apprehension in the mystical spaces he seems to conjure rather than merely record. The notion of the artist as cross-cultural communicant, as Downey describes it, speaks to both the inherent architectural properties of communications systems—even those as rudimentary as one in which the artist makes tapes in a caravan, shooting in one town, editing on the road, and showing the work to the people of the next town. His acknowledgment of the difficulty inherent in re-creating that kind of experience in the gallery space that one senses in his highly mannered end-works reconfirms the fact that artists must see video works as no more than a function of a peculiar architectural equation involving both a sense of space and time.

In contrast to these artists who use the technical potential developed by commercial TV for phenomenological investigations, William Wegman employs its stylistic conventions like those of the TV pitchman and stand-up comic. Taken out of context through the use of low-resolution monochrome video and a kind of exaggerated self-consciousness, these devices concentrate both on the aesthetic factor of the relationship between the viewer and the work itself and on the social factor of audience relationships with TV programs in general. Wegman's tapes are authentically humorous in their confrontation between traditional comic expectations and his droll deadpan style. His interest in psychology, as well as his sense of humor, is particularly evident in the tapes featuring his stoic Weimaraner hound, Man Ray, which play on the dog's behavioral

William Wegman: *Selected Works Reel #6*. 1975. Black & white, with sound, 20 mins. Courtesy Castelli-Sonnabend Tapes and Films, New York.

quirks and responses so as to change radically our notions of behavioral psychology and TV humor.

Another artist who explores viewer relationships with television is Douglas Davis, who has been unusually successful in integrating into his work an understanding of the political and sociological implications of video. In his *Austrian Tapes,* a record of a live performance broadcast on Austrian television in the summer of 1974, Davis specifically attacks the prevailing notions of viewer passivity in relation to both television and art in general. By suggesting and actually acting out a direct encounter with the viewer, in which the participant is invited to undress in front of the television screen and touch like parts of the body with the artist, Davis at once exploits latent fears of the cold impersonal medium and emphasizes its one-to-one nature (the intimacy of the viewer-monitor relationship, in contrast to the mythical "mass audience"). There are few artists who have so thoroughly explored this aspect of the medium; perhaps only Joseph Beuys and Hans Haacke have gone so far in their exploration of social and political systems in general.

Peter Campus deals with video systems as direct functions of reality. His color tape *Three Transitions* (1973) investigates the disparities between mechanical perception and the depth of human perception, modified as human perception is with the capacity for understanding. As well as making tapes, Campus creates complex sculptural systems using television cameras, video projectors, and picture monitors as primary structural elements while relying upon light-defined fields. Campus also relies on the process of familiarization, as the viewer gradually comprehends how he or she has become an integral part of the piece. *sev* (1975) represents a major stage in the growth of his work, a body of work that is characterized by this kind of "live" video installation.

In *sev,* Campus continues to create an induced experience with the viewer-participant affected neither by the artist nor the viewer directly, but by the work itself in conjunction with the passage of time. Less diffuse than many of Campus's earlier works, *sev* exists as a concentrated cluster of light glowing in a severely darkened space. The video projector is placed quite close to the wall, casting an extremely intense image of the viewer-participant that imparts a sense of looking through the wall rather than onto it. Ultimately this work, like *mem* (1974) and *Anamnesis* (1973), induces in the

Douglas Davis: *Images from the Present Tense I*. 1971. Black & white, with sound, 30 mins. Courtesy Electronic Arts Intermix, Inc., New York. Photograph: Peter Moore.

viewer a condition in which the notion of fixed points of reference gives way to the experience of multiple points of view and multiple points in time. *Anamnesis,* probably more than any of Campus's earlier works, represents the previous phase of this artist, originally schooled in experimental psychology. In a way far more elegant and surely more deeply moving than the illustrations used to illuminate the theories of Gestalt psychologists like Edgar Rubin, Kurt Koffka, or Wolfgang Köhler, Campus creates experimental epistemologies that provide the situation in which a participant will formulate a learning experience to support the reality of his immediate perceptions of the situation Campus has created. In *Anamnesis* (meaning to recollect or to reproduce in memory) the viewer enters a large dark space to find one pool of light created by a narrow-focused spotlight. Upon entering the lighted field, the viewer-participant sees his or her image video-projected, life-size, on the facing wall. As the viewer stares at his or her image, he is unaware that it is composed of a live, real-time video signal as well as an image taken off a delay loop three seconds past and superimposed upon the live image. It is only upon moving that the viewer-participant discovers that he is pulling a three-second time trailer behind, at every instant leading to some sort of mediation between the two dissimilar though simultaneously apparent points in time and space.

> With video you can do everything and still watch—it's a continuation of your life.
>
> —Nam June Paik, 1975

Finally, we must consider *TV Garden* (1974), Nam June Paik's tour de force consisting of twenty-five color TV sets all playing Paik's international version of "American Bandstand," *Global Groove,* in all colors, shades, and hues. In an essay written in 1965, Paik noted that "Cybernated art is very important, but art for cybernated life is more important, and the latter need not be cybernated." Combining interests in Zen, cybernetics, painting, musical composition, and a global politics devoted to survival and constant change, Paik blazed the trail for a whole generation of video and conceptual artists.

The *TV Garden* featuring *Global Groove* is indicative of Paik's

eclectic character. The garden is indeed real, as the array of television sets nestles among dozens of live greens, some of which partially obscure the view of certain screens while others frame as many as three sets at a time. The tape itself starts out with a Broadway version of a 1960s rock and roll dance set to Bill Haley's "Rock Around the Clock." The scene changes rapidly to a Korean drum dancer, then to Allen Ginsberg as his face is distorted by a video synthesis process invented by Paik and the Japanese engineer Shuya Abe in 1969. The tape continues to jump wildly from a Navajo Indian, to the Living Theatre, to a Nigerian dancer, to a 1930s "fan dancer," and back to rock and roll. Originally produced to be a broadcast on a United Nations satellite, the whole collage was a spoof on Marshall McLuhan's notion of global village. Implicit in Paik's tape is the threat of the possible misuse of global communications systems in a commercially overdosed fashion, analogous to the fate of U.S. telecommunications ever since 90 percent of all available VHF broadcast frequencies were awarded to commercial developers way back in 1953. But on a far simpler level the work is as enjoyable as Paik could make it; it is a concerted effort to make a truly avant-garde form both entertaining and effective.

There is no way in which a completely comprehensive view of American video activity could be presented; but probably more important, it is doubtful whether such a view should be presented. The range of artists using television for one reason or another is not enough to warrant any categorical statement of their similarity based on the use of a particular medium. There exists, after all, a tendency toward the narcissism of the performer as well as a tendency toward the anonymity of the documentarian; a tendency toward the straightforward representation of realities acknowledged in any number of ways as well as the creation of abstract, nonrepresentational imagery; and all of this within what is too often simplistically labeled "video art." Clearly, the development of artists' use of television is the result of a number of simultaneous phenomena, some of which are grounded in the advance of communications technology, some of which are grounded in art's recent tumultuous history, and some of which are the direct result of a more general planetary malaise involving politics, biology, and the complex interface that links them both. Like other forms of contemporary expression, the roots of artists' television in America are deep and complex.

Nam June Paik: "Allen Ginsberg" from *Suite 212*. 1975. Color, 8 mins.
Photograph: Davidson Gigliotti.

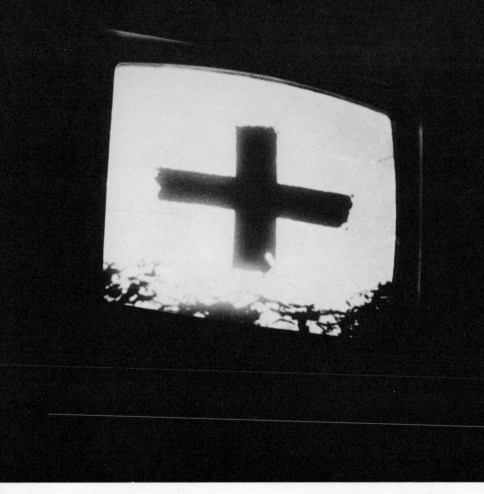

Chris Burden: *Do You Believe in Television?* 1976. Black & white. Photograph courtesy the artist.

In 1934 Walter Benjamin, writing in his essay "The Work of Art in the Age of Mechanical Reproduction," noted that in the early part of the twentieth century a good deal of futile thought was devoted to the question of whether or not photography was an "art." The primary question, Benjamin observed, had not been raised: Had the very invention of photography not transformed the entire nature of art? Likewise, the current boom in video work should not prompt us to debate over the legitimacy of this work's claim to art-ness, but should lead us to examine changes effected by video throughout art—and, by extension, throughout the full range of our cybernated society.

KISSING
THE UNIQUE OBJECT
GOOD-BYE

ROBERT STEFANOTTY

In this article Robert Stefanotty, himself a former art dealer, takes the art marketplace to task for not supporting the making and distribution of video artworks in an aggressive way. Part of the problem, according to Stefanotty, lies in the necessity to alter one's basic conception of the very nature of artworks, their properties, and their status as unique objects.

Among other suggestions, Stefanotty proposes that video tapes, in order to become more available, be cheaper in price; a system of international, as opposed to local or national, distribution should be undertaken; copyright situations should be clarified; and a new system of copyright peculiar to video tapes should be devised.

As an art dealer, Robert Stefanotty specialized in artists' video distribution. He is currently working on a doctorate in art history.

It is truly amazing how retarded the marketplace for contemporary art has been in its approach to video tapes. When one considers the mercantile fervor that has given "real" monetary value to such unlikely candidates as posthumous Duchamp readymades and Hundertwasser silk screens in signed editions limited to ten thousand, it is confounding, to say the least, that some of the most creative work of the last eight or nine years has been relegated to unsalable status.

Perhaps the main deterrent to serious progress has been the notion of the unique, rare, and consequently ever more valuable object—a notion that plagues almost as many artists as clients and that many merchants have been riding into the ground for quite some time. It often gives undue value to the most unlikely artistic droppings and constantly reduces me to fits of laughter at the most inconven-

ient times. Of course there still are many of these objects around—that is not the problem—but in terms of video tapes in a highly object-oriented market, the conception of what art is needs one hell of a lot of rethinking.

One of the supreme joys of video tapes is that they self-destruct. They wear down gracefully; and the very nature of the medium is such that they cannot be limited. I say "cannot" realizing full well that some merchants have tried to structure video tapes so that they are metamorphosed into "rare objects" and that technology is rapidly being introduced to increase a tape's life-span and its indiscriminate duplication. The sheer perversity of these quests seems self-evident.

Now I should go slowly here because I do not want to offend anyone whose "life is video." First of all, let me explain that I am a passionate, circles-under-the-eyes video follower, the sort of person who can listen to Taka Iimura telling me for forty minutes (full face, profile, and back of head) that he is "Taka Iimura" and not slip into a state of catatonia. I can also see the same artistic merit in an excellent video tape as in a first-rate bronze, but there the similarity ends.

It logically follows from the nature of video that a large clientele should be sought out, and until "video tapes" become "television" plain and simple, the following steps could be taken:

1. Drastically reduce the selling price of video tapes and present them in at least half-hour programs or groupings. (What would you as a client think of paying three hundred dollars for an eight-minute tape? Pretty ludicrous, no matter whose eight minutes they are.)

2. Now that there is no longer a problem with European/American standards, set up an international distribution system, making sure that permanent monitor rooms are available in every representative city center so that the work is readily accessible for everyone to see.

3. Arrange a reasonable percentage scale with artists so that secondary distribution, and consequently mass markets, can become a reality. A middle road between marketing a painting and a copyright product such as a book should be worked out.

4. Work with major hardware corporations, cable television stations, educational institutions, and even airlines to heighten the

awareness of how a broad spectrum of artists have used and are using the medium in diverse ways, and how beautifully they have been and are succeeding.

When my clients—and we have several private people who are building excellent video collections—ask me whether video prices will go up, my usual response is "God forbid. We have enough inflation." If we are lucky, in a short time videotape prices will go down, and the market will expand accordingly. As it expands, even if the artists' net goes down to thirty percent—which, I maintain, will be necessary to give distributors outside the New York gallery a fair forty percent discount, so as to keep all selling prices uniformly the same—there will be increasingly more money coming back to the artists and the gallery, which in turn can be used to back more projects and to pay our respective rents.

A MEANS TOWARD
AN END

JUDITH VAN BARON

In this article Judith Van Baron documents the recent history of video as an art medium. She emphasizes the main problem central to all video art —the availability of equipment. And she traces the step-by-step development and the growing awareness and sophistication of several video artists—Paul Kos, George Bolling, Terry Fox, Howard Fried, and Joel Glassman.

All the artists discussed in this article have created works that were not primarily intended as art. That is, they serve a twofold purpose: The works were made for pragmatic purposes first, and only second do they stand as artworks.

Judith Van Baron is an art critic and well-known lecturer on museum administration. She is director of the art gallery of the San Jose State University in California and art editor for the Soho Weekly News *in New York City.*

Although it seems as if everybody has it these days, in the late 1960s there was not exactly an excess of video equipment lying about. Those few who had it generally made it available to others. All over the country enclaves of practicing video neophytes popped up almost overnight. Thus, while the history of video is short, it is also diffuse; and it is not as complicated a history as the plethora of practitioners may suggest.

Throughout the country a relatively common pattern evolved: Video was first a documentary tool, then an experimental technique, and finally a fully realized art form. The pattern may have developed with somewhat more alacrity in New York, but can be more easily observed in a smaller, rather isolated example. A study of one

video enclave—Paul Kos, Terry Fox, Howard Fried, and George Bolling—reveals the curiously common development rather precisely.

In about 1969 George Bolling, curator of the de Saisset Art Gallery and Museum of the University of Santa Clara, began to use a friend's Portapak to document exhibitions and performances. Since the practice of video art obviously required equipment, everyone in the area interested in the art form became involved with the de Saisset program—it was the only Portapak in town. John Battenberg and Gary Remsing were two of the first artists to have their exhibitions documented by Bolling. The resulting tapes were merely records of the exhibits—cheaper than film, more immediate, in black and white, and including audio, a feature not terribly important then but one that would soon hold tremendous significance. Bolling employed his own technique of filming, guided, he admits, by documentary necessity, not by aesthetics.

The first documentaries were technical experiments. It was, however, with the work of Paul Kos, a teacher at the University of Santa Clara, that the potential for video was first recognized as a tool and eventually as an art form in itself. Bolling taped a performance for Kos in 1972 called *rEvolution*. Rather than documenting an exhibit, the filming of Kos's performance expanded into the conceptual—the awareness of real time in videotaping and its correspondence with the conceptual *modus operandi* began to assert itself.

At about the same time an exhibit at the de Saisset entitled "Fish-Fox-Kos" introduced Bolling to Terry Fox, and some documentary tapes of Fox's work were made. Later, Howard Fried and Joel Glassman joined the Portapak circle. However, rather than using the medium as a documentary tool, Fried and Glassman approached it from the point of view of filmmaking. Their first efforts were not documentary—instead they created performances not with an audience in mind but with the video viewer in mind. The result was a different kind of staging, one with a single viewpoint from the camera and without audience participation.

By 1973–74 the evolution had reached a peak. Several of the artists had acquired their own equipment from NEA grants. They had discovered, experimented, and were ready to move in other directions or find more permanent solutions. Video either had to play the leading role in their work, or be subordinated in favor of other interests. Here's what happened.

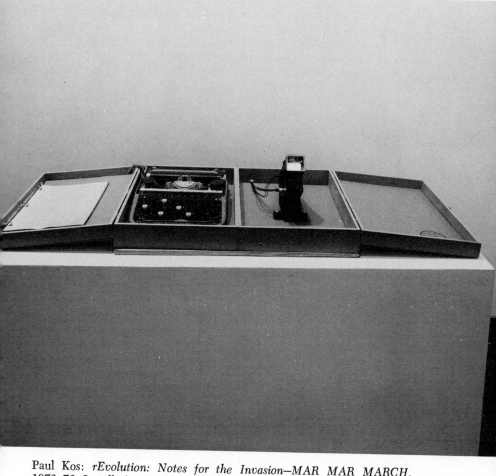

Paul Kos: *rEvolution: Notes for the Invasion—MAR MAR MARCH*.
1972–73. Installation Institute of Contemporary Art, University of Penn-
sylvania, Philadelphia, 1975. Photograph: Will Brown.

Terry Fox made his first video tapes in 1969–70 as documentations of performances that were taped by George Bolling. He took the medium rather for granted at first—it was cheaper than film and more useful; he could tape performances, both audio and visual, to send to places where he could not appear in person. The major problems were technical—equipment was rare, and editing was impossible without an editing deck, which nobody had.

In 1970 in New York, Fox made his first tape that was not primarily documentary. *Tonguing* simply presented a close-up of Fox's tongue. It was done primarily with the tape in mind but was minimal in terms of content and staging and very primitive in terms of technique. From there on, Fox used video occasionally and made enough tapes to develop for himself a recognition of video as a viable art form. He claims, however, that he never took it very seriously and did not consider it a substitute for the experience essential to performance.

In 1972–73 Fox made a series of thirty-four tapes for children. These he took very seriously but not in terms of video art. Rather their instructional value for children was important. They taught art concepts in an inventive way that children found fascinating. The medium of video was chosen largely because the subjects were too intimate for performance and because of the special appeal and attention-holding power TV has for children.

Thereafter Fox used video in a spontaneous way. When it was available, he used it—the peculiar situation dictated the form. Since he is now most interested in sound, video has become a useful tool, since it provides audio. But Fox does not consider the video tape to be the artwork itself. And although he agrees that art is essentially communication, he adamantly feels video is a bad means of achieving it. There is, in Fox's view, too much sensory deprivation in video for it to function properly as communication and thus art. For Fox, then, video remains a tool that is used for, but does not adequately relate the actual experience of, art. It is otherwise too boring, in his view, to warrant more of his involvement, and he does not expect an audience to sit through it either.

Similarly, Howard Fried uses video whenever it seems appropriate and, like Fox, does not consider himself primarily a video artist. However, while Fox views it as a tool, Fried sees video more as a

Howard Fried: *Sea Sell Sea Sick at Saw Sea Soar*. 1971. Black & white,
Sea
with sound, 50 mins. Photograph: Tyrus Gerlach.

technique. Perhaps the difference arose right in the beginning. Fried did not begin using video for documentary purposes. He set out right from the start to do the performance for the tape and not for an audience. Consequently, his first tape, made in December 1970 with George Bolling, was staged for video, the controlling factor being where it was shot from, not where it was seen from. The elements of filmmaking were involved; the physical characteristics of video added their own peculiar qualities.

Fried often combined a number of elements into his video tapes so that the performance existed on a number of levels, all of them somewhat independent of each other and of the final tape. *In Traction*, an example of his multiformat work, was done originally as a performance. Video was utilized not to document but rather to make a tape that was not necessarily the same observation as that made by the audience. A minirestaurant was set up that included musicians, a waiter, and other persons drinking coffee. Spectators were able to view from four different points, and cameras filmed from four different points. While the audience observed the entire scene, the video cameras focused on and followed the movement of one object, the cream pitcher, making it the star of the tape. The final tape did not represent the whole performance as such; it rather was only a means to an end, a filming technique by which the final result was filtered out of the total experience. The purpose of the whole artwork was at least partially political—a statement about media filtering information. Ultimately, the video was only a means toward an end. The tape would be viewed later, but it was a fragment of the total artwork, albeit the embodiment of the idea.

Thus while Fried used video as a form in itself and not as a documentary tool, it did not become the focus of the work. Fried continues to work in video and in film, choosing his medium according to the needs of the piece and still maintaining the respective levels of sophistication that distinguish the two. He feels the artist has no particular responsibility to communicate, and thus the use of video as a technique needn't be particularly articulate.

Paul Kos, has arrived at a very different use of video. He comes closer to considering it as an art form—almost as a sculptural component. Kos began working with Bolling in 1969 on the exhibition documentation and shortly thereafter began working more with

Howard Fried: *Fuck You Purdue*. 1971. Black & white, with sound, 30 mins. Photograph: Larry Fox.

Howard Fried: *Fuck You Purdue*. 1971. Black & white, with sound, 30 mins. Photograph: Larry Fox.

video in mind. At first the tapes were explanatory, shown as part of the sculpture exhibition to elaborate and provide information. Eventually Kos began thinking in terms of installations—more and more video played an integral part, though still in a rather mixed-media manner. Finally, of course, the installation became more and more video-oriented, centering on the video itself while still depending heavily on the performance and sculptural installation. The pieces and elements were carefully integrated, and unlike Fried's *In Traction,* the video was not to be and could not be viewed outside of the installation.

With *MAR MAR MARCH* (1971), Kos reached a well-defined, carefully plotted video staging. A video tape was done of a series of typewritten pages on which *MAR MAR MARCH* was repeated across and down the page. It was synchronized with the sound of the typewriter translated into a staccato rhythm. Two-by-four beams were laid across the floor of the gallery so that the viewer was forced to step to the rhythm of the sound while approaching the monitor, which was about one-inch square. All the elements formally coalesced as the viewer reached the monitor. For the viewer, the video was both the bait and the reward. The viewer was carefully programmed to perform correctly, and the message was coded on multilevels—visual, audio, physical, literal, and symbolic. The viewer was not allowed to remain passive.

For the artist, the whole elaborate installation, staging, and multi-level aesthetic codes became the total performance—choreographed and directed. The atrist, however, did not have to perform. In essence the only one privileged to view the whole performance was the artist, since only he (and his assistants) could experience it in totality—including anticipating and conditioning the performance of the video viewer. The artist put them through their paces and, like any other creator of a meditative art object, became distant, yet with full knowledge of exactly what the viewer was doing.

Kos continued to present multileveled installations, choreographing the process of creation and integrating the video as the object, the component, and, in a sense, the director of the event. *Tokyo Rose* and *Aren't Any, Are Tinny* (1975–76) continued the development of this elaborate use of video. Kos remains involved with video as an art form separate from performance and film, though definitely with

Marlene and Paul Kos: *Tokyo Rose.* 1975–76. Black & white, with sound, 11 mins., 10 secs. Collection The San Francisco Museum of Modern Art. Photograph: Paul Kos.

a blood relationship to each. It is the most sophisticated aesthetic use of the medium and the least boring for the spectator.

George Bolling, the man behind the camera in the early stages of the work of Fox, Fried, and Kos, saw the whole process from quite a different vantage point. His own tapes are far more intellectually aesthetic: There seems to be more of a conscientious clarity in the balance between the artwork as process or concept and the artwork as object and content.

Originally Bolling was involved with the technical limitations of video—real time, black and white, spontaneity, and the lack of editing. The need for flexible choreography and control of the hardware channeled his approach somewhat differently from that of his contemporaries.

Bolling was also in a position to observe and evaluate. He became aware primarily of the element of time, discovering no essential distinctions between live and taped performances if they are seen on the monitor. Time became invisible. He observed that in film the emphasis was on the image, while in video the issue was time, and image was secondary. Further, he discovered that in video one learned to shoot fluidly and work for the moment. As the purpose changed from pure documentary to performance for the video, the whole process became more integrated; the performing artist came behind the camera and worked from both points of view.

By 1973 Bolling gave up his work with documentation and began to work on the video feed to the Exploratorium of the Jupiter Flyby. Here he confronted the issue of time on a massive scale, and the confrontation between time and the viewer became preeminent. He hoped to develop a sense of following the space mission and wanted to relate the events as they occurred—if a viewer had watched over a period of five days, he or she should have gained a sense of the whole mission as it occurred in time, even if much of the data was nonspecific or too technical.

In observing the past six years from his particular vantage point, Bolling recognizes the trend toward erasing the distinctions between video and film. As the technical limitations break down or alter—spontaneity, editing, black and white—the aesthetic structures controlling one (film) will begin to engulf the other (video). Already he admits the possibility of discussing the work of Kos, Fox, and

Fried on a stylistic basis just as one can discuss the style of movie directors. And when aesthetic systems are interchangeable, the medium settles into conventions.

Whether video imitates film, is used only as a tool or technique, or becomes a sophisticated conceptual sculptural component in itself is a matter of individual preference among the artists who employ it. In 1969 one Portapak brought together a group of artists. They began in much the same manner and followed a similar pattern. They arrived at widely divergent attitudes toward video. It is this multiplicity that will continue to make video so fascinating and so universally effective an art form.

VIDEOSPACE:
VARIETIES OF THE
VIDEO INSTALLATION

INGRID WIEGAND

The special requirements and problems inherent in art video exhibitions and installations have in some ways influenced the very content of much video art. In fact the special demands for such art video exhibitions have led to a type of video genre that Ingrid Wiegand identifies in this article as "video installation work."

Some of the properties of actual video installation that have made it the subject of exploratory video artworks include the essentially sculptural nature of such installations, as well as the realities of the exhibition situation. The author points out that the video image "creates another, entirely different space for the three-dimensional," which results in a space-time interplay that has only recently been explored. Thus the author contributes additional thoughts concerning the role of "time" in video, an idea that is discussed elsewhere in this volume as well.

Ingrid Wiegand is a video artist who has written extensively about video art for the Soho Weekly News, The Village Voice, *and the art magazines. In this article she discusses several New York video artists, including James Byrne, Peter Campus, Maxi Cohen, David Cort, Davidson Gigliotti, Beryl Korot, Shigeko Kubota, Nam June Paik, and Ira Schneider.*

One of the interesting art-world phenomena is the way that opportunities to exhibit condition the kind of artwork that is created. Art critics and artists have lamented this situation in terms of its influence on style—works in a certain mode have had their fashions

181

largely because they were the works a substantial number of galleries chose to show at a given time. For the same reasons, the existence of larger galleries, especially in SoHo, has encouraged the creation of large-scale sculpture as much as sculptors of large-scale works have created a demand for large galleries. Yet in no medium has the influence of exhibition possibilities made itself more felt than in video.

Since the first Sony Portapak reached these shores, the question of where and how to show tapes made by video artists has presented a problem for everybody concerned. By their nature artists' video tapes do not generally lend themselves to broadcast situations. By default—because the only audience ready to look at artists' tapes could find them there—the showing of artists' tapes has fallen primarily to art galleries and to such gallerylike exhibition spaces as The Kitchen in New York, A Space in Toronto, and/or in Seattle, and so on. The galleries and their *semblables*, in turn, soon found that a TV image that might require as much as an hour of patient, informed looking was not for most of its patrons, who were accustomed to flitting through an entire year of an artist's work in less time than they took to flip through a coffee-table monthly. It also became evident that the shows that worked—that got an audience other than the colleagues and friends of the artist on show—contained video installation works. So what has happened in video in terms of what is being shown is just that—the video installation work.

Of four artists exhibiting during one week in 1976, three—Shigeko Kubota, James Byrne, and Peter Campus—showed installation works. It is not that the works of the three artists are at all related, or that the fourth (Frank Gillette) was in any way less significant, *au courant*, or what have you. It is simply that if an artist wants to get his work shown in a respected situation, the chances are about three times better if he works in terms of the installation piece.

This is not to suggest that this situation is redolent of corruption on either side. It is not. What happens is that any artist has, at any moment, rattling about in his mind any number of pieces he or she wants to do. However, recognizing that the one that can exist as an installation piece is the one most likely to see the light of a showing causes that piece to rise to the surface and be completed. The gallery

or show-space director, similarly, merely recognizes the fact that the existing gallery space lends itself to one kind of work more than another. And of course, there are video artists whose primary format is the installation work.

The video installation piece in itself also has several unique properties that make it fertile for exploration and rewarding for the artist and the viewer. It is essentially sculpture—sometimes environmental, sometimes a sculptured object. But it is also sculpture with sound (often), and it is sculpture with time, because the work's static elements are part of the temporal event unfolding on the screen. Finally, the video image creates another, entirely different space for the three-dimensional configuration that sculpture normally inhabits. The room, the hill, the desert on the monitors are of another dimension than the one the work as a whole occupies, and so the work extends into the room, the hill, the desert even as it remains in the space. If there is no image on the monitor, it becomes spaceless and so intrudes its nondimensionality on the work. The implications of this space-time interplay of installation video works has only begun to be explored, but a number of artists have made deep inroads on the territory.

James Byrne produces black-and-white video works that are, as he says, formally concerned with the monitor image, but they are far more expressive of an experience of space, and especially of the kind of video space that we take for granted. This is the space that we are unconsciously familiar with in film and broadcast TV—a space that is created entirely by camera movement and perspective. In order to watch a moving image, we constantly accept the fact that what is, for example, an *apparent* movement of the room we are viewing, is actually the movement of the camera.

What Byrne does in his works is to put the entire experience of viewing the moving video image into question and so shake up our viewing experience that we can see more freshly. In *FloorCeiling* a single video tape is shown simultaneously on two large monitors, one lying faceup on the floor and one hanging directly above it from the ceiling. The entire real-time tape, some ten-odd minutes long, consists of Byrne manipulating a camera so that it variously looks down toward the floor, where a monitor shows what the camera

sees, and looks up at the ceiling, where a second monitor acts similarly. Throughout, Byrne moves the camera primarily onto himself, so that he appears in the various perspectives.

What is unexpected is that Byrne's image is acceptable to the viewer in both the floor and ceiling monitors—both in the actual monitors of the installation and the monitors seen on the tape. *FloorCeiling* thus momentarily destroys the notion of up and down, making it very difficult to sustain a notion of "correct" perspective, and makes it hard simultaneously to apprehend what is happening visually and to analyze intellectually what he is doing. While *Floor-Ceiling* would be interesting as a straight tape, the installation work extends and multiplies its experiential possibilities.

Peter Campus is also a master of the unexpected image and image movement, but in very different terms. Possibly no one else has used the technology of video to create such elegant visual plays upon the human presence in space, in both tape and closed-circuit installation works. In his most effective closed-circuit works, the viewer is constrained to see only a very specific image of himself—limited to a specific aspect, position or orientation—projected on a wall, on a screen, or on plexiglass. In recent work he has used infrared cameras and video projectors focused on the walls of darkened rooms to create the image of the viewer. A group of three pieces, shown together (1975), formed three variations: *sev*, in which the rectangular image of a viewer standing in the camera field is projected sideways, so that the viewer's vertical is horizontal on the wall; *cir*, in which the imaged viewer appears diagonally within a trapezoidal projection; and *bys*, in which the imagee/imager finds his hand or face on the wall to be upside-down and greatly enlarged. The overall effect of Campus's work is to force the viewer to participate in a very physical way in a different kind of space than that which his kinaesthetic sense informs him he is occupying.

Maxi Cohen's *My Bubi, My Zada* is essentially a personal video documentary of the artist's grandmother, but was shown within the context of a video installation. It is interesting in our present context primarily because it points up some of the aspects of installation video. The installation itself involved a re-creation of the kind of living room Cohen's grandmother would feel at home in. As the

Peter Campus: *East-Ended Tape.* 1976. Color, with sound, 8 mins., 30 secs. Courtesy Castelli-Sonnabend Tapes and Films, New York. Photograph: Bevan Davies.

pièce de résistance, the monitor on which the tape was shown was encased in a large carved wood "console" with doors that closed to hide the television set when not in use.

Cohen's work is essentially a straight playback tape, and an installation is not really necessary to viewing the tape, nor does it enhance its viewing possibilities. On the other hand, by placing the tape on a monitor as part of this installation in a gallery situation, the traditional living room becomes a participatory sculpture for the viewer, and the tape becomes like television. Like television—and in contrast to, for example, Byrne's piece—the tape never refers to the installation in which it exists.

David Cort has been playing what he called variously "video games," "videophones," and "videomirrors." These are all closed-circuit installation works in which the viewer either interacts with another or with a predetermined image, such as a work of art. The results are invariably humorous if not outright funny. In the earliest piece, Cort used variously split screens in which two people would try to make one face. In more recent works, he has used elaborate chroma-key and matté technology to superimpose the viewer—or the viewer's hands, legs, mouth, or face—onto an existing image. In an installation at New York's Metropolitan Museum of Art, Cort enabled the viewer to insert his image into major works of art, such as the statue of Queen Nefertiti.

Davidson Gigliotti has developed a particular configuration for the multichannel format of installation video works. Multichannel pieces, which simultaneously present the images from two or more video tapes on two or more monitors, require the viewer to distribute his attention among the channels and to maintain a continuous state of awareness of alternate image possibilities. Gigliotti's work, however, has involved the use of several monitors (usually three) to give an expanded view of a natural site: a mountain, a hill, a mountain stream. Each monitor, however, shows only a part of the total image, because each of them is arranged in the same position as one of the cameras that shot the scene. In *Hunter Mountain,* for example, one monitor shows the left-hand view, another, the peak, and a third, the lower slopes on the viewer's right. The events in the tapes are minimal, such as those a landscape watcher might note: the nod of

a bough, the glitter of running water. The effect Gigliotti achieves is one in which the scene appears as if perceived through a selected set of telescopic windows rather than as a real-time event recorded on tape.

Beryl Korot produced a major work in the multichannel format called *Dachau 1974*, which consists entirely of footage of the tourist-haunted remains of the infamous Nazi concentration camp. An artist who also works as a weaver, Korot brought to the installation form a particular awareness of the way the parts of the images become interlaced. She almost "wove" the work, so that each main segment in each channel is cut into 7½- or 15-second parts, separated by brief pauses of gray leader. These subsegments are ordered in various rhythmic, repetitive combinations, so that footage is repeated, but at different edit points. As a result, a couple, walking toward the viewer between the two barbed wire walls of the camp approaches the viewer repeatedly on first two and then four channels, sometimes from a distance, sometimes from a closer position. Each time, the woman drops a small white paper or handkerchief from her pocket, and each time the paper remains on the ground as she walks forward. In another sequence, a very long shot of the barracks reveals a tiny figure repeatedly coming out of a doorway and disappearing at image left as several tiny figures file diagonally across the screen from the right.

The piece also uses tensions set up by slight differences between images on alternate monitors, such as when the couple described above appears in the middle distance on monitor one and in a closer position on monitor three. Another dimension is created by the fact that Korot continually moves from the inside to the outside of the camp and of the buildings, and back to the inside again.

Shigeko Kubota assembled three video works in a darkened room to create a kind of videospace in which multiple, color video images were incorporated into structures normally associated with sculpture: a square column, a stair, a box. And in fact these are sculptures —specific three-dimensional forms created as works of art—that incorporate video images. In this instance the video works constituted installation works individually and an installation collectively, integrated by their involvement with the theme of Duchamp's *esprit*.

The column piece, *Marcel Duchamp's Grave*, stretches from floor to ceiling and contains ten monitors adjusted for various color tonalities. The single video tape playing simultaneously on all monitors shows Duchamp's tombstone, inscribed with the penetrating alliterative aside: *"d'ailleurs,/c'est toujours,/les autres qui meurt"* ("Anyway, it is always others who die"). The column of monitors is reflected in a thirty-foot-long pier glass, which repeats the column and inverts the viewer's perspective. As a result, the column appears to continue below the floor, creating the physical sense of a deep space below floor level.

The stair piece incorporates four color monitors showing a highly edited video tape of *Nude Descending a Staircase*, after Duchamp's legendary cubist painting. The nude descends endlessly in all possible modes of descending; fast, slow, rightside up, upside down, etc., in various colors, in various partial or total aspects. It is the total descendance, and successfully conveys, destroys, and re-creates the experience of its title. Like the *Grave*, it is a multimonitor, single-channel work. The box piece, *Chess*, uses a small color monitor that underlies a small plexiglass chessboard with plastic chess pieces so the viewer can "play" chess alongside Duchamp and Cage, the subjects of the tape playing on the monitor below. The tape is in the form of colorized images of Kubota's photographs of a game between the two, accompanied by the audio record of the game that was wired to be recorded as a musical work.

Nam June Paik simultaneously showed two very different installation video works in two different spaces. *Anti-Gravity Video*, a two-channel piece, involves twenty monitors hung facedown from the ceiling in the dark, so that the serious viewer is required to lie down and watch up to an hour of small fishes swim by. The fish appear to move leisurely from set to set, intermittently transformed by colorization and video synthesis and intercut with visions of a skywriter looping through the blue. Rather than an underwater piece, Paik sees this as a sky work in which the fishes are in flight. The irregular arrangement and various sizes of monitors as well as the style of editing, which is peculiarly Paik's, make it appear as if there were more than two channels.

The second piece involves a totally different and unique bag of tricks. In a darkened room, an open J curve of twelve monitors mounted on pedestals displays twelve stages of what appears to be

Nam June Paik: "Nixon" from *Medium Is Medium*. 1969. Color, 7 mins.
Courtesy WGBH-TV. Photograph: Mary Lucier.

a darkening sphere—a sequence familiar to us from the phases of the moon. Technically, what the viewer sees are eleven doctored rasters and a blank, darkened screen on the twelfth monitor. Normally the raster occupies the entire screen, inscribing it with the lines, which, when modulated, "draw" our TV image. Paik, however, has created circular rasters where the lines traced vary in length on each monitor until, in the eleventh, they just brush the screen briefly to draw a sliver of a scythe.

Ira Schneider creates multichannel installation works that are meant to be moved through rather than observed *in toto*. *Video '75; An Information Collage for the First Day of the Last Quarter of the Twentieth Century* (1975) used nine monitors placed at different levels in white columns of different heights and distributed over a large space. The rectangular columns faced in different directions so that the viewer could follow paths through the piece to view the images in various sequences and combinations. Eight of the monitors were used to play eight different five-minute tape loops, including tapes of sky, Western landscapes and rockscapes, animals, and people on an automobile trip. One tape consisted entirely of the burning of an eighty-foot puppet at the Lenten festival in Santa Fe, New Mexico, to the accompaniment of fireworks. Another showed sports, news, and stock-market bulletins in the form of character-generated material, and another was entirely concerned with the setting up of the piece itself. The ninth monitor was a live image on an eight-second tape-delay unit, which confronted the viewer with himself in disconcerting remembrance of time almost immediately past. By wandering through these images, the viewer collected a composite image of Schneider's vision of America at a particular time.

I have created an installation work that incorporates a surreal vision of an automobile ride and extends it simultaneously on four channels, with four video projectors placed so that the viewer sees the projected images as four roads rushing away in four directions. Each channel deals with a ride in one of the four cardinal points, oriented as much as possible so that they are related to the gallery wall position. Each image is taken from a fixed camera centered between the front seats of a car, and shows a wide-angle view of the dashboard and the windshield. The road image seen through

the windshield is sometimes shown as a wipe (split screen), so that the left-hand side may show an earlier part of the ride—say, a city street—while the right-hand side shows the highway. Since the camera is fixed, the car interior remains unchanged, so that the car appears to be in two places at once.

The rearview mirror also serves as the locus of an intruded image, sometimes showing locations other than those visible through the windshield. The repeated rearview mirror motif, however, are eyes in extreme close-up staring at the viewer, while a monologue— voice-over apparently related to the eyes—quietly insists that "Escape is impossible. There is no way you can drive far enough to get away from here. You have to understand that there is no way . . ."

SIGN-OFF DEVOTIONAL (MEDITATION AND PRAYER): A LEARNING DEVOTIONAL DELIVERED BY THE PERSON, THE RIGHT HONORABLE REVEREND TRAIN

RON WHYTE

The final event of the day's programming for most commercial video stations is the sign-off devotional, frequently referred to as the "sermonette" or meditation and prayer. We close this book with a script for a video tape by Ron Whyte, a playwright and video artist, that takes the format of the sign-off "sermonette" as its subject matter.

Mr. Whyte's sermonette is not, of course, a serious sermonette. Rather it serves as an example of how the format and structures of commercial video programming are used by today's video artists, who manipulate the conventions of the past in order to stimulate new thoughts for future video.

Choral theme: Heinrich Isaac's Missa Carminum, *"Benedictus."*

Visual: Large styrofoam (funeral) cross decorated with huge satin and paper flowers comes into focus out of white blur.

Cross blurs out to white. Then minister comes into focus and music slowly fades.

Brief silence.

MINISTER (*boldly*): It is easier to fall downstairs than it is to run uphill. But is it really? Have you ever tried to fall downstairs? Try it now. (*Long pause.*) Notice how difficult it is, once you put your mind to it? Now run uphill. (*Long pause.*) You see how much easier it is to run uphill than it is to fall downstairs? I hope you will keep that in mind next time you must choose between the easy-appearing way and the difficult-appearing way. (*Short pause optional.*) You will now, I hope, think twice before choosing. (*Bows head, prays.*)

Music up, under soft.

Our father, as we travel through this world, going to and fro, we ask that when the signposts of life point in the correct direction, we shall have the courage to go that way, no matter how difficult. Show us the way, Lord Jesus, and we shall follow where thy finger indicates. Amen.

Minister blurs to white.

Music up full.

Cross comes into focus.

Hold briefly.

<div align="center">END</div>

INDEX

Page references for illustrations are in **boldface** type.